Sports
Photography

Sports Photography

How to take great action shots

Arthur Shay

. . . the Lord . . . He aims for something to be always a-moving . . .

—William Faulkner

Contemporary Books, Inc.
Chicago

Library of Congress Cataloging in Publication Data

Shay, Arthur.
 Sports photography.

 Includes index.
 1. Photography of sports. I. Title.
TR821.S55 1981 778.9′9796 80-68598
ISBN 0-8092-5962-1
ISBN 0-8092-5961-3 (pbk.)

Published by Contemporary Books, Inc.
180 North Michigan Avenue, Chicago, Illinois 60601
Manufactured in the United States of America
Library of Congress Catalog Card Number: 80-68598
International Standard Book Number: 0-8092-5962-1 (cloth)
 0-8092-5961-3 (paper)

Published simultaneously in Canada by
Beaverbooks, Ltd.
150 Lesmill Road
Don Mills, Ontario M3B 2T5
Canada

This book is for the late Francis Reeves "Nig" Miller, *Life* magazine's greatest but unsung sports, crime, news, and feature photographer. He was my mentor and my friend. He could eat fire and chew glass, and his resourcefulness helped him get the impossible picture before much of today's sophisticated equipment was available to the photographer.

To straighten out several legends: It was Francis Miller who first mounted a camera in a hockey net, ran his wires under the ice, and shot goalie's eye view pictures. It was *not* Miller, but the great Wallace Kirkland, who mounted his electronic flashlights underwater in that pond and killed eight fish with his first exposure.

Arthur Shay

Contents

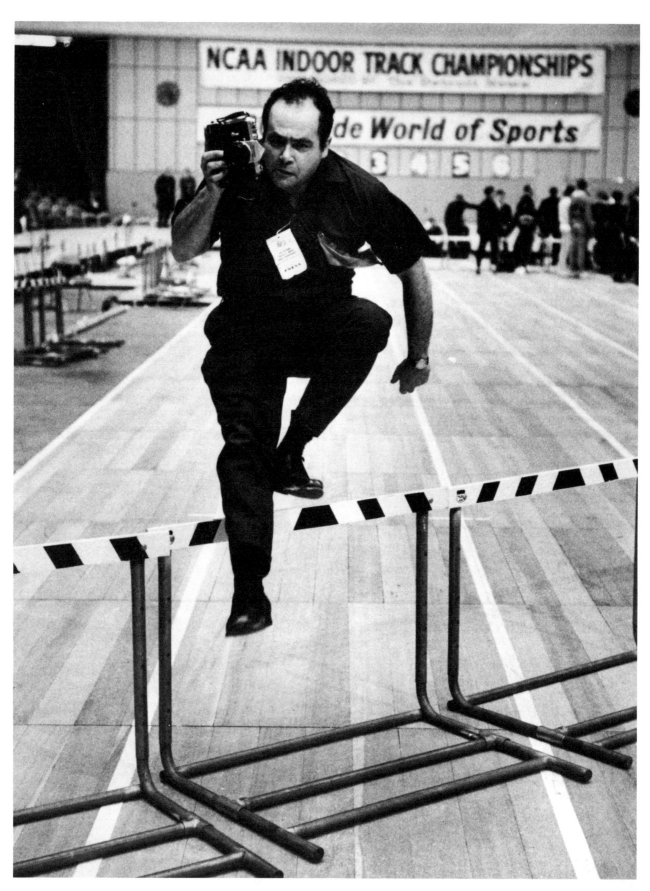

On assignment for *Sports Illustrated* at a track and field meet, author-photographer Arthur Shay warms up by hurdling, his eye on the runners ahead of him.

Foreword

More than half our country's population now participates in some sport or another, and this revolution has brought with it an almost miraculous revolution in sports photography. Today, sports photographs can be seen everywhere. They loom above us on billboards, where the vigor and attractiveness portrayed are used to advertise cars, cigarettes, vacation resorts, and health foods. On the TV screen sports photography takes the viewer into the football huddle, the baseball dugout, the dressing room of the jubilant victor, and the hallway in which the distraught ice skater explains why his pulled thigh muscle has forced him to withdraw from the Olympic event he and his partner had expected to win. Those forty-inch TV zoom lenses and equally advanced "telephoto" microphones are in business, a multibillion-dollar business, for exactly this purpose: to put you, the sacred viewer, there, even though you're watching from a continent away.

In an Olympics in which thirty different events occur on the same day, four to six cameras are dispatched to each event; the best of their takes are instantly put on tape. In a control room, an editor-producer watches all the tapes and pieces together the best of the sports coverage for you to watch. Obviously, you, as home viewer, can see a broader variety of Olympic events than a visitor who is on the scene. You also see more of a football or baseball game than the average grandstand fan.

To the surprise of many viewers and readers, a television network uses a vast quantity of still pictures to enhance what it puts on the air. In the case of ABC, many of these come from the innumerable sporting events our staff covers. We're always looking for good sports pictures—and good sports photographers.

As I write, ABC is preparing to cover the winter Olympics in Yugoslavia and the 1984 summer Olympics in Los Angeles. All over the world we have photographers poking their

telephoto lenses and sequence cameras at the men and women who will be competing before ABC's TV cameras. The pictures, both black and white and color, will help introduce these people to publications around the globe. At the Montreal Olympics ABC's photographers included such world class sports journalists as Ken Regan, whom you've seen in TV ads in which he teaches famous sports figures to use their new automatic Canon cameras, and Art Shay, the author of this book.

Regan, Shay, and others—John Zimmerman and Heinz Kluetmeier of Time Incorporated, plus several of our own staff photographers— are often sent to produce pictures that photo editors will be pleased to run in their publications, ideally in advance of our TV showing or, perhaps, in time for a larger feature next year. For a medium as current and instantaneous as TV—with satellites and all—we sometimes have long deadlines. The point is, anything we can do to have one of our programs or events pictured in the printed media actually helps our viewers and also attracts more of them.

As a former press photographer, I am familiar with the problems and opportunities involved in sports coverage. I know that there are certain limitations built into various events—lighting, weather, even sideline passes! One of the greatest obstacles we encountered in covering the Montreal Olympics, for instance, was the security-zealous Canadian police. Even we of ABC had to line up twice a day for sideline passes.

I knew, unofficially, that such resourceful photographers as Shay and Zimmerman were somehow fabricating counterfeit tickets out of tickets for previous days, and thus getting in. One day, our very great superslow-motion cinematographer, Robert Rieger, tired of standing on the police line, shared one of Shay's counterfeit tickets, and both were able to work in a good position from which to cover the start of several sprints. Many a good picture was ruined by an overofficious guard shaking a photographer's shoulder and saying, "M'sieur, your foot is over the line . . ."

Please note that no serious quarrel resulted from all this; all of ABC's photographers, and most pros, understand that the picture is the thing. Resourcefulness plus orderly, polite retreat almost always pay off in good pictures—certainly a lot better pictures than you'd get if you were thrown out of a stadium!

The light in the main stadium at Montreal was fantastically changeable. The broad sombrero-type roof, a run of weather in which clouds covered the sun intermittently, and other conditions kept every sports photographer busy changing exposure settings. *Sports Illustrated* and the other Time Incorporated magazines had something else going for them that we at ABC lacked during those particularly hectic weeks.

Eastman Kodak had just developed its new Ektachrome E-6 films, which offer a fine high-speed exposure index of ASA 200 plus finer grain and better color rendition than its immediate predecessor (Ektachrome-X), which we had brought along. On the other hand, Kodak was developing all professional photography right on the Olympic grounds—free of charge. How could you beat the prices when you were running sixty rolls a day of some forty sports?

This, obliquely, brings me to the subject of how much film a photographer should shoot on a sports assignment. The answer is enough film to get the picture in both color and black and white, and about 20 percent more for good luck. I once sent Art Shay to the stock car races at Daytona, Florida. He perched on the roof of a grandstand with four cameras aimed down the stretch. He felt that he had shot too much film, and with ten minutes to go in the big race he almost started to trek down to the finish line on track level, but something made him stick where he was. In the very last half minute of the race two of the cars crashed and careened over the finish line, knocking out a third car. Shay got the whole sequence, thanks to the 200–600mm Nikon zoom lens on one of his motorized Nikons.

The still photographer working for a TV network has a special problem. With ten to twelve cameras frequently scattered over the field, TV coverage is so thorough that people expect to see every flurry of unusual action, every unpredictable aspect of an event. They expect to see every puff of smoke coming from a disabled car, even if it occurs, say, at Indy

two miles from the starting line. The still photographer can only choose what he or she regards as the optimum position for good pictures and perhaps move around a little. We really don't expect our still photographers to come up with the odd, out-of-normal-range picture, though sometimes they do. What we do expect is comprehensive coverage that gives the feel of an event. Here is where the good photographer's eye shines over that of a mere picture taker. Often one unpredictable picture, shot at a distance from the main action, captures the spirit of the event better than a hard action shot does. For example, one of the greatest pictures ever made at the Indy 500 shows a stunned sparrow perched on a track-side fence, his back turned to the roar of the engines of cars racing past. *Life* magazine used it as a big opening picture for one year's Indy story. Wherever possible, we also expect to get a series of good close-up horizontal portraits of the contestants, combatants, or competitors—especially the hot ones—so that we can flash one on the screen after a great feat or, alas, a tragedy. This allows us to show our viewers a close-up of the performer that puts him or her into human scale, thus making the athlete all the more remarkable.

Of course, luck plays a great part in sports photography. Many a great picture has been lost because a photographer was changing film, arguing with a sidelines guard, or listening to a question of an amateur photo buff. One year at the Indy 500, Art Shay heard a roar in the "Brickyard" (the cobblestone-paved infield where all races start and finish), whipped around with his camera shooting,

and got the only good close-up sequence of Unser's car coming apart with Unser miraculously escaping. Even though *Sports Illustrated* had four superb photographers around the track, they used part of Shay's sequence on their cover.

To young photographers anxious to get into sports photography I can recommend no better procedure than to start covering local schools' sporting events and show the results to the individual in charge of covering area sports at local TV stations. It would be prudent for these aspirants to shoot a few frames over the shoulders of the TV crew, showing the station's equipment in use on location. These pictures should show something of the stadium, field, or track in the background to set the scene.

The next step after selling a few of these unsolicited public relations pictures is to scrounge a sidelines pass for an upcoming event. From then on, becoming known as a dependable producer of good sports pictures is a matter of developing your skills and preventing the eagerness in your personality from being construed as overconfidence or extreme aggression.

You can learn a lot about sports pictures by studying the TV sections of your local newspapers and TV guide magazines. You will see that we love close-ups of good hard action. You will also see that no matter how small the pictures are in the ads, they read easily—you don't have to wonder what sport is being touted.

Good shooting!

Rick Giacalone
Vice-President
ABC-TV

Sports Photography

1

Cameras for the Sports Photographer

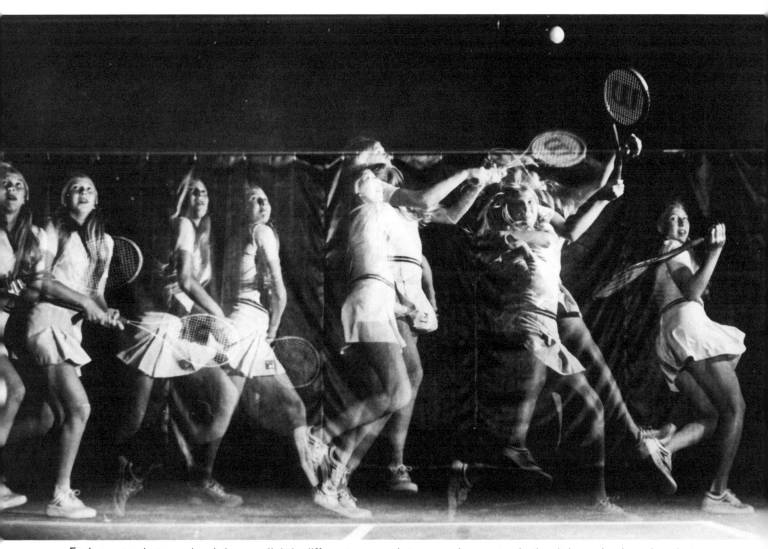

Each sports photographer brings a slightly different approach to an assignment, whether it be a simple action shot or a multiple-exposure study.

For many years sports photographers converted ordinary press camera equipment into sports cameras. This was done by making fast-focusing levers and improving camera beds to take long telephoto lens shots.

The ancient and honorable Graflex, a huge single-lens reflex camera taking 4x5-inch film (some models using 2¼x3¼, 3¼x4¼, and 5x7), weighed twenty-five pounds and was toted around between 1890 and 1950 by myriad press and sports photographers. You could look down into the hood and see on a ground-glass screen what your lens was seeing in reverse. When you flipped the shutter release, the image disappeared as a mirror popped up with a thumping noise. When the mirror flipped up, a curtained shutter came down with a satisfying metallic whir. If you had your slide out and your exposure was correct, you had a picture.

The shutter speeds offered an incredible range—from 1/30 to 1/1000 second. These were quite accurate and trouble free, and many a historic sports picture was taken with one of these monsters set at 1/333 second.

Baseball photographers generally used 5x7-inch Graflexes, which were more or less permanently mounted on top of the press boxes at most big league ball parks. An intricately machined Big Bertha lens—up to forty inches in focal length—could be set for the three bases and home plate, and the photographer could aim his cannon and focus by sliding the lens levers into position for the developing play.

Of course, before the Graflex, Eadweard Muybridge, a scientist-photographer of Victorian times, had accelerated his ancient noncurtained shutters with rubber bands and was thus able to shoot a multicamera sequence of a galloping horse (in 1878!), proving that it did indeed run with four hooves off the ground at some point in its stride. But it was the Graflex that spawned the age of sports photography.

Several German reflex cameras, notably the Ihagee Exakta and the Pentacon, copied the Graflex principle of using a mirror to bounce

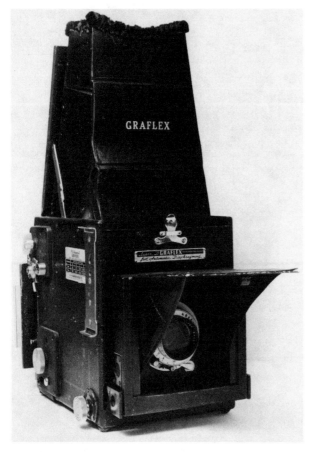

The Graflex single-lens reflex camera prevailed from the turn of the century into the 1930s. This later model is still used by some fashion photographers who like to see a full-frame 4×5-inch reflex image. The automatic diaphragm on the front of this camera formed the system now refined and used in the modern single-lens reflex.

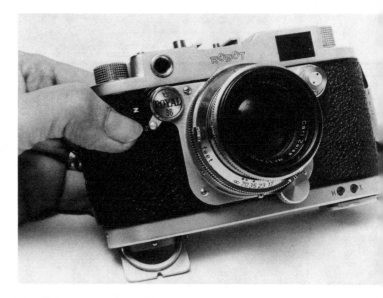

The Robot camera is still imported from Germany. It uses a range finder, not a reflex viewing system, and shoots six frames a second but is not very efficient with long lenses.

the image onto a viewing screen. The Robot Company in Germany developed a miniature camera with a spring motor that allowed shooting at about five frames a second. Focus was done by range finder. Bell & Howell's spring-wound, seven-frame-a-second camera died of poor accessory design.

EVOLUTION OF THE MODERN SINGLE-LENS REFLEX CAMERA AND MOTOR DRIVE OR SEQUENCE CAMERAS

Suddenly, in the early 1950s, Pentax of Japan produced a single-lens reflex camera that offered mirror viewing with a plus. That mirror popped up as soon as you released the shutter, *but then it popped right back into place*. This left your eye free to find another picture instantly. Other manufacturers soon produced comparable cameras.

Shortly thereafter, Nikon, also of Japan, introduced its motor drive. This remarkable battery-driven attachment permitted owners of the Nikon single-lens reflex camera to push a button and take 3½ pictures a second. Instead of a single, possibly shaky frame of a football player catching a pass, the motor permitted you to shoot four or five pictures of the play. Thus, the photographer or editor could pick out the best of the frames.

It wasn't long before most professional newspaper, magazine, and commercial photographers were sporting these expensive tools and the wonderful new lenses, wide angle to telephoto, that were designed to fit them.

Canon, Pentax, Olympus, Minolta, Topcon, and Leica all produced motor drives for existing cameras or designed cameras that whizzed the film through.

One manufacturer, Charles Hulcher of Virginia, began modifying his military camera models that could shoot up to sixty-five frames a second to take Canon, Pentax, or Nikon lenses. This permitted sports photographers covering once-in-a-lifetime situations to get sixty-five rather than a mere four or five frames of a crucial knockout, home run, or touchdown run.

As the 1980s began, some two million single-lens reflex cameras were being sold in

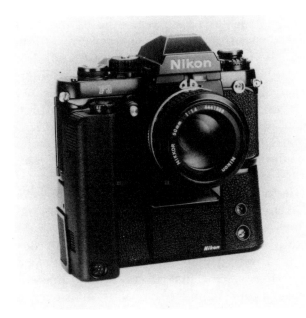

The latest model of the Nikon, the F3, with MD-4 motor drive, capable of six frames a second, is the current state-of-the-art favorite of sports photographers.

The $5,000 Hulcher, a 35mm 100-foot load camera that Charlie Hulcher of Virginia developed from his military ballistics cameras, can use ordinary single-lens reflex lenses and can shoot ten, twenty, forty, and sixty-five frames a second at shutter speeds going up to 1/10,000 second!

the United States each year—the result of an average yearly growth of 15 percent. "More than half our sales," says Nikon official Jon Ehrenreich, "are to people with a heavy interest in sports photography."

The early lead Nikon gained among professional sports photographers with its motorized Model F camera has held up through a series of improved and more sophisticated cameras—all still capable of using the original series of superb Nikon lenses. Today, about 75 percent of all professional sports photographers use Nikon cameras and lenses.

But wait! Olympus produced a small reflex camera with a motor drive and sophisticated metering system that wooed many amateur photographers and a few professionals over to their extensive system.

Then came Canon with an equally magnificent series of heavy-duty professional gear centered around its own F-1 camera and motor drive and dozens of lenses. Drawing the amateur with TV commercials pointing out the virtues of fast-film-transport view motor drives and winders on its AE-1 series, Canon suddenly loomed as the giant in the amateur market, outselling Nikon among amateur sports picture shooters by some four to one!

But wait! There on the TV screen we see Olympian Bruce Jenner with a motor-driven

Minolta, shooting (simulated) freeze-frames, one after the next, implying that the *really* keyed-in sports photographers use Minoltas.

Continuing along the path of single-lens reflex miniaturization that Olympus pioneered in the '70s, Asahi Pentax created a five-frame-a-second series of reflex boxes that can do all the things competing cameras can do.

Fighting back, Contax, an old German name coeval with Leica, came up with a quartz-controlled beauty that was designed by the same engineers who beautified the Porsche! (Contax's latest model has an in-body film winder. The camera is of ordinary size!)

Not to be outdone, Leica, the grandfather of all quality cameras, introduced its own reflex line with motor drive.

There are others: Konica, Vivitar, Yashica, Chinon, and so on.

Hasselblad and Rolleiflex also make magnificent sports picture machines that take 120 film, providing a 2¼x2¼-inch negative. Mamiya and Bronica have also spawned complete lines of cameras, lenses, and motor-driven film.

So, what is the tyro sports photographer to do? Believe Cheryl Tiegs' push for Olympus or Bruce Jenner's endorsement of Minolta? Go with Canon, which sells more motor-wind cameras than anyone else, or Nikon, which has retained its popularity with the pros?

In sheer durability, Nikon and Canon seem to have the most to offer. They hold up under adverse conditions, not to say abuse, better than most of the other cameras. Nikon makes more than sixty interchangeable lenses for their boxes, while Canon offers fifty.

If price is a consideration, the best place to get a clear idea of the actual selling price of most camera equipment is in the camera section of the Sunday *New York Times*. On these three or four pages tucked at the back of the Arts section, just before the Gardening pages, the highly competitive New York camera stores fight it out, dollar by dollar. This

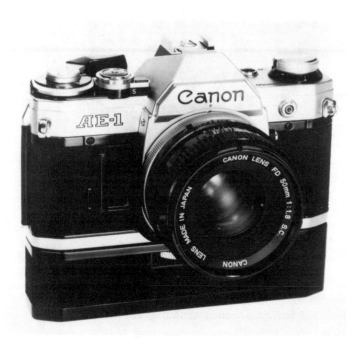

Canon's popular AE-1 series provides a motor wind for sports photographers. Olympus, Pentax, Minolta, and others compete heavily for the amateur motor drive–sports picture photographer.

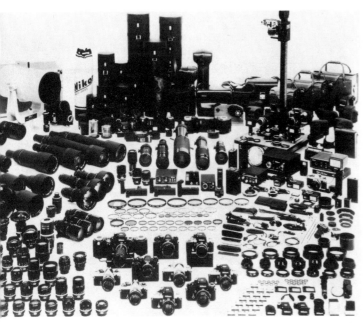

Nikon's extensive product line is typical of their awareness of the sports photography market.

should serve as a guide for you when you walk into your local friendly camera store. In some cases your local dealer will grimace, because the advertised prices may be lower than what he pays for an outfit. This occasionally occurs because New York stores become overstocked after having received huge discounts for buying in quantities.

Before discussing some of the sophisticated innards of cameras suitable for sports photography, let me quote the great Edward Steichen, who once said that no photographer has yet exhausted the possibilities of the simple box camera. Therefore, the camera you now own or use—a plain workhorse type of single-lens reflex—may be a perfectly good tool for starting out. Of course, you won't have the advantage of shooting 3½ to 6 frames a second. Still, one of the world's greatest sports photographers, Neil Leifer, began his career as a high school sidelines shooter with an old Nikon and one 300mm telephoto lens. He would talk his way into professional football games in New York—games at which *Sports Illustrated* had its own photographers—and shoot frame after frame of hard action. He would race home, develop his take, then print all night and bring his pictures up to *Sports Illustrated*. He built a reputation for being pushy to the point of being obnoxious—but

also for being a good sports photographer. One day I was supposed to go to Texas to shoot a college game for *Sports Illustrated*. I couldn't get back to Texas in time from Chicago, so I sent Neal from New York. He got a cover and a couple of inside pages, and was on his way to a fine career.

If you have a second camera box or can afford to buy one, you can easily manage baseball, football, or soccer coverage with a zoom lens, or a 200mm lens on one camera (with extender on for deep sideline plays and off for shooting from behind the goal at oncoming action) and a shorter lens—say, a 105mm—on the other. (See Chapter 2 for more information.) That extra box will also provide the luxury of shooting black-and-white film in one camera and color film in the other.

But let us suppose that money is no object in obtaining the right equipment for general sports coverage. What should you buy?

The bad news, of course, is that all new equipment is expensive. The good news is that the camera market is exactly like the car market. People tend to trade away their troubles. If you think of sports photography as a business venture (and there's no reason you shouldn't), your total investment will be less than what a cab driver invests in a good used cab.

There are few businesses you can enter so cheaply. Ultimately, the decision of which camera to buy should depend on how the camera feels to you—how the viewfinder looks when you put a 300mm lens on the camera and trigger the motor at a car passing outside the camera store.

THE CAMERA BOXES

Along with their motor winders and motor drives, the big news in modern cameras suitable for sports is their electronic sophistication, especially in the automatic modes of exposure. There are cameras that you activate by giving priority to the shutter, that is, by choosing a shutter speed first and letting the camera choose its own lens opening. There are also cameras that use the aperture-preferred system. First you choose your aperture. Then, the shutter, working through the meter—or

indeed, *as* the meter—picks out a shutter speed based on the amount of light coming through the lens at the aperture you've selected. This speed might be a 1/389 second or any speed from a full second to 1/2000 second!

Here, then, are some of the fantastic machines capable of turning out the greatest sports pictures ever made.

Nikon

Venerable old models of the Nikon dating back to the early 1950s appear on used-camera counters. These Model Fs and FTNs can occasionally be bought at bargain prices. If you find one in good condition—one owned by a sports photographer who just used it for shooting his or her TV screen during every Olympics—this might be the perfect backup camera for you if you eventually choose Nikon. The drawback of these reliable ancients is that the back comes off when you change film and can easily be dropped and mashed into the ground during a sporting event. When the lip of the back is bent, it can be straightened with needle-nosed pliers or a rubber hammer.

The old Nikons sometimes appear with motor drives. The power for these comes from batteries in an eight-cell case or in a smaller, attached power unit. If the motor can drive the shutter and the price is right, the chances are that you can put quite a few more miles on this rig.

Nikon's next series of cameras, the F2As, came along in the early 1970s and was designed for the professional photographer, especially the sports photographer. The back no longer dropped off; it hinged outward.

Its through-the-lens metering system uses two CdS cells that use an intricate averaging method of reading the light that hits the focusing screen. Two small 1.5-volt silver oxide batteries, quite expensive these days, provide an illuminated scale in the finder that tells you whether your exposure is over, under, or just right. This whole metering system is activated by a slight out-thrust of the film winding handle and must be pushed back to the camera when not in use; otherwise the batteries run down swiftly. The great thing about this

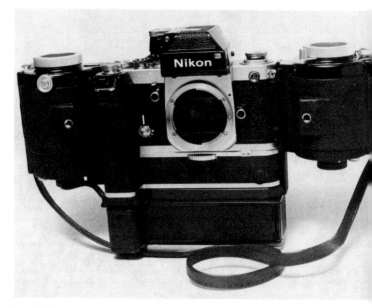

The 250-exposure motorized Nikon permits thirty-three feet of film to be shot without reloading. That's about eight ordinary thirty-six-exposure rolls. Sports photographers took to this camera (and competitors' models), but in general they have abandoned them because they are heavy and unwieldy except when used on tripods, as in a space shoot.

system is that once you lose your battery power you also lose your camera meter, but the shutter works just fine. The shutter is mechanical, not electronic, accounting for this virtue. A neat feature of this camera is that the ASA film speed scale goes from ASA 6 to ASA 6400, permitting you to push film as far as is now comfortably feasible and still meter your pictures.

Nikon makes about ten different finders and some twenty viewing screens plus six backs.

The feature that excited sports photographers when this camera came along was the magnificent MD-3 motor drive that gave 3½ frames a second plus the capacity for automatic rewind. This camera became the first that permitted you to push a lever and hear the satisfying whir of your film going back into the cartridge. The main disadvantage of this film rewinding comes into play outdoors in very cold weather, when static electricity marks occasionally appear on black-and-white film, usually Tri-X. Another disadvantage is that using the motor drive for rewinding severely drains the nickel cadmium batteries, known in the trade as nicads, that most pros use in the motor. (It is possible to use eight

AA cells in the motor. The nicads, in two handy clumps, are easy to install and remove for recharging.)

For the amateur, but not exclusively, Nikon built a small mechanically shuttered FM model and a companion FE. These boxes are relatively inexpensive compared to the F2A, and the power winders cost only about a third of the F2A motor price. They are not quite as dependable but are generally reactivated by a sharp tap of the hand because their prime fault lies in the battery contact area. These boxes take most of the Nikon lenses. Their own lenses, a new series called AI (for ''Auto Indexing''), fits the meters of these cameras. Older non-AI lenses of Nikon manufacture can be used with these boxes or converted to AI lenses by Nikon at a nominal price. Converted, these lenses work with the meters of the FMs and FEs.

The FM's virtue is that its shutter is *not* electronic. It is mechanical, like the shutters of the traditional reflex cameras, Nikons and others. Two silver oxide batteries work the gallium photoiode metering system.

If your batteries die, the camera shutter works fine, and you've merely lost the use of the meter.

The FE, which looks exactly like the FM, has an electronic shutter. When those two batteries fade or fail, you lose the metering capacity of the box and, alas, also the electronic shutter. When the FE's batteries run down, the camera is still usable because it has a built-in mechanical shutter that operates at 1/90 second, and also Bulb. No matter where you set the shutter dial—1 second, 1/250, 1/1000—your actual shutter speed is 1/90. (Setting the shutter on B will give you bulb as usual.) When the battery power is gone, your meter doesn't work either. Thus, you must estimate a lens opening that will work with 1/90. If your camera is on a tripod and you are taking long exposures, you're in luck, thanks to bulb. No sports photographer I know travels without an auxiliary meter and some spare batteries.

If you're nervous about carrying extra batteries, the FM is much more practical. Of course, when you set the lens opening into the FE it obligingly picks out one of those spiffy shutter speeds like 1/523. But no photographer ever lost a great sports picture because of that extra burst of speed that 1/523 supplies over a mere 1/500. No exposure was ever ruined by such a minuscule difference. On the other hand, battery failure has cost many photographers lots of pictures.

The MD-11 motor winder that came out when the FM and FE were introduced is usually the culprit in battery run-down. The MD-11 winder has an on-off switch, but it's terribly easy to leave it in the on position during long intervals between shooting and even when putting the camera away. Fortunately, it is just the two meter batteries, the small MS 76s, that expire. The motor-winding AA cells work only when they drive the shutter and film.

If possible, get the MD-12 winder, which has the great improvement of a special circuit that turns off the meter batteries every 50 seconds. Each time you press the shutter, you start another cycle of 50 seconds. Thus, you are never without meter power, and if you put

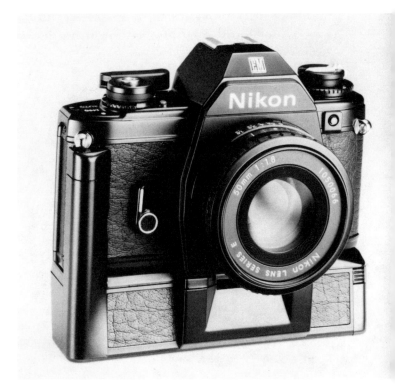

Nikon's EM camera is practically idiot-proof and relatively inexpensive. It gives sports photographers a carry-around camera that is capable of two frames a second and capable of working as a spare box while another Nikon body is mounted, say, to a long lens.

the camera away, it will switch itself off in 50 seconds.

Nikon has also entered the cluttered field of plastic cameras with a relatively inexpensive, lightweight, idiot-proof automatic camera. It is called the EM. It is an aperture priority camera like the FE. It even has a built-in beeper that tells you when your exposure is wrong! The EM also has an automatic battery cutoff, a welcome feature for the neophyte.

The EM takes all AI lenses, and Nikon has been making a series of cheaper lenses (plastic in the gearing) that have done quite well in tests. Inexpensive Nikon lenses of 35mm and 100mm are now available at half the price of regular Nikon lenses.

At this writing the sports cameras that offer state-of-the-art technology are those in Nikon's F2H series, which is like the F2A series but takes 10 frames a second rather than 3½! It is heavier and uses a beam splitter rather than a flapping mirror, but it does give you 10 frames a second.

The new working standard for the sports photographer is the Nikon F3 with the MD-4 motor drive providing 6 frames per second.

The F3 at this writing is the state-of-the-art camera for sports photographers, with Canon moving up fast. The F3 is all electronic. It uses a sophisticated and trouble-free quartz oscillator to provide shutter speeds from 8 seconds to 1/2000. One amazing feature of this vast range is that when you set your lens aperture (an aperture preferred system), the metering system sets the shutter at the precise speed called for. That is, where most cameras offer 1/250, then 1/500, then 1/1000—the F3 comes up with exposures like 1/267, 1/511, 1/1289, or 1/1945! The viewfinder comes up with the closest conventional number and a tiny plus or minus indicating whether you are exposing a little more or less than that number. You can easily override all of these intermittent speeds and use the camera as a plain action camera. A bonus on this class of camera is the multi-exposure switch. You can

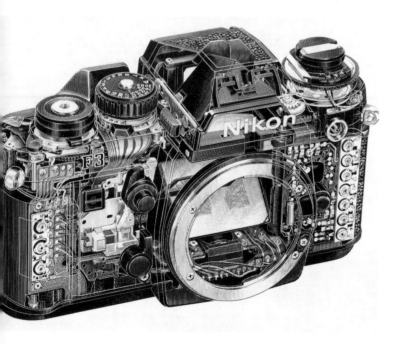

Nikon's Visible F3 is a combination of precision engineering and space-age electronics which combine in the Nikon F3 accuracy, strength, and dependability.

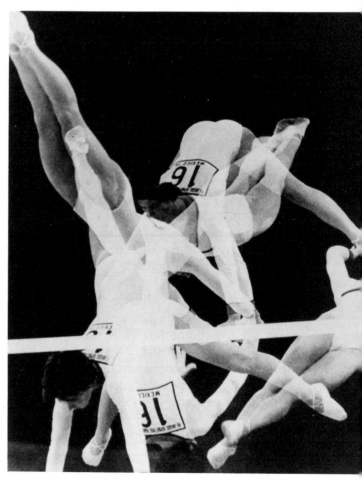

The six exposures of this gymnast are perhaps two or three too many. It's the black background that makes this kind of exposure feasible.

keep shooting on the same frame. Just remember to cut the exposure down so that the cumulative exposure equals the time of the proper shutter speed and lens setting.

Canon

If Nikon opened the doors of repetitive frame photography to the professional, it is Canon that has been wooing and winning the amateur sports photographer in droves.

Canon's solid and dependable F-1 model was a worthy competitor of the Nikon F2A series. It still is. Its metering system is an old-fashioned needle that must be lined up with a small circle. It is CdS powered. Its 1/2000 second shutter speed and film setting to ASA 3200 are more than adequate. The camera feels like a solid piece of machinery. Its bayonet mount is not quite as swift as the Nikon's for lenses, but it is just as sturdy. In the prism war with Nikon, it asserts itself fairly well.

Canon made a fairly automatic model, the EF, which was an early shutter priority camera. The trouble with it was that the shutter

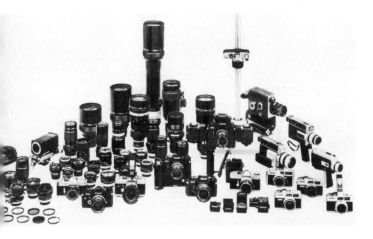

Canon's line.

wheel tended to move as you flicked the film winder. Thus, you could end up shooting at 1/15 when you swore you set the dial at 1/125.

Still, this is now a collector's item and, when in good condition, it makes a fine backup body for the new sports photographer who can keep his or her fingers from flying along that culprit dial.

Canon's big contributions to sports photography for the amateur are the A-1, the

much advertised AE-1, and the AT-1. Canon's fantastic long telephotos are generally cheaper than Nikon's.

The AE-1, a worldwide best-seller (and deservedly so), is light to the touch but solid in feel. Its shutter speeds go from 2 to 1/1000 seconds. It is a shutter priority camera. You choose the shutter speed; the camera sets the lens aperture for you.

Its accessory winder shoots two frames a second, so it is not a blazingly fast transporter of film.

If you decide that the camera's automation is not to be trusted in certain situations—shooting directly into the light, for example—you can override the entire system and make a simple old-fashioned camera out of it that is completely battery-dependent.

LEDs blink in red and a flickering M on the finder reminds you that you are in control momentarily.

An expensive six-volt silver oxide cell works the shutter and the metering system. The AE-1, like Nikon's FM, for example, has no mechanical shutter and goes dead when the battery does.

Canon's similar but less expensive AT-1 and AV-1 have minor variations, making them somewhat cheaper than the AE-1 but worth appraising for feel and utility.

Canon's flagship camera at this writing is the A-1. It is a sophisticated machine that provides accurate center-weighted exposure readings. It permits you to set film speed up to an unbelievable ASA 12,800! You can use it as an aperture priority camera or a shutter priority camera. If you're disinclined to set either shutter or aperture and have the energy to set the letter P (for Programmed exposure) into your camera, the camera will set *both* shutter and aperture.

Canon makes special electronic flashes for this camera that do everything but get releases from your subjects. Manual override is a cinch. If all the blinking LEDs make your finder seem like mission control and interfere with the aesthetics of your vision, you can turn all these displays off. That expensive six-volt silver oxide battery is the heart of the A-1.

A motor winder gives two frames per second; a motor drive, more expensive but more

powerful, gives four frames per second, which is adequate for most sports photography.

Contax

An interesting dark horse contender in the motorized sports camera field is the Contax RTS, which is made for Carl Zeiss of Germany by Yashica of Japan. Yashica also makes a cheaper line of boxes and lenses (about half the price of the Zeiss line of lenses) that are adequate and fit the Contax.

Contax was the first company to use quartz-crystal control, giving great accuracy and causing little wear and tear on the system, promising reliability and long life.

Several advertising-sports photographers have switched, at least temporarily, to the Contax RTS because of its Porsche-like construction and its new approaches to old problems. It would literally take a course of intensive picture taking to learn to use this marvelous machine.

Konica

Konica's FS-1 is a novel camera that is easily adaptable to light-duty sports photography. It has a built-in battery-holding bulge on the right side of the camera, and the film automatically winds through as fast as you can press the shutter button. It has an adequate system of automatic exposure. Its disadvantage is that it offers no means for manual film winding. It uses alkaline AA batteries, which aren't nearly as expensive as the silver oxide batteries some cameras use. It has shutter priority and modern gallium arsenide phosphide photdiode metering. Konica also makes a more orthodox reflex camera, the T-4, that has a relatively slow auto winder—1½ frames a second. It is made of an extremely durable polycarbonate resin.

Leica

Quite simply, Leica has always been the Rolls Royce of the camera world, in quality as well as in price. The Leica R 3 is heavy and lacks some of the LED sophistication of the other new reflexes. Leica makes a motor that

fits its R 3 MOT. Leica is expensive. But if you're the Rolls Royce type and have strong arms, you should try the Leica. Its reputation for reliability is unparalleled in a world in which mechanical failure is practically a given.

Minolta

Minolta is another hard-hitting company that has used TV to convince the well-heeled amateur that Minolta is the greatest sports camera of the age. It's a good, well-designed camera. The XD-11 provides both shutter and aperture priority. It permits the photographer to control automatic exposures and has an accurate Seiko shutter. Its motor winder performs at two frames per second, which is adequate but not overwhelming.

Catering to the sports photographer, Minolta has built its XK model, which has a built-in nondetachable motor that moves the film through the camera at 3½ frames a second. Like the Nikon F2 series, Minolta provides a bulk film attachment that takes thirty-three feet of film for 250 exposures.

Pentax

In these days of climbing silver battery prices, Pentax's MX is a dependable little brute that follows the tough tradition of Pentax reflex cameras. Its mechanical shutter and matching-diode arrangement for exposure metering make a good team. An accessory winder claims two frames a second while a much advertised motor fires away at a respectable five frames a second. The MX's electronic twin, the ME, is fine if you're not frightened of getting stuck in the woods without a spare battery or two. Various colored LEDs light up inside these cameras, and various prisms and screens will delight the tinkerer. This is an extremely small camera, suitable for people with small hands or purses.

Olympus

Speaking of small and innovative cameras, it is worth repeating that it was Olympus that brought the single-lens reflex down to practi-

cal palm size. Olympus's OM-1 began the downsizing move (in lenses as well as cameras), and Olympus quality has steadily improved. Many press photographers use the Olympus and its three-frame-a-second accessory winder. The OM-1N has LEDs and other improvements over the original OM-1.

The newer OM-2N is an ingenious first. It measures the light that falls on the *film* at the moment of exposure, then instantly speeds up or slows down the shutter to provide the most accurate exposure. Nikon's new F3 has adapted this system. The OM-2N can provide automatic exposure up to *two full minutes*. You set up the camera, go buy that straw hat, come back, and if the camera is still there, you have a fine picture of the square at night!

There are other motor-drive cameras, but these are the main contenders. Go to your favorite camera store. Invest a few dollars in film. Shoot a roll with each, in the various modes. If you live in a city that has good rental equipment, you might want to rent one of the cameras listed, along with several lenses, and cover your favorite sport.

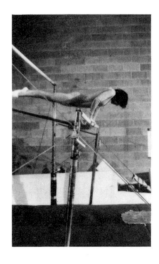
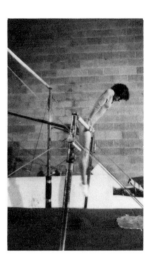

The modern motorized-winder camera, which advances the film from two frames a second to sixty-four frames a second, gives the sports photographer a definite advantage.

At 3½ frames a second with the Nikon FM, the gymnast is captured in her uneven horizontal bar event. The editor can then choose a sequence or single shot.

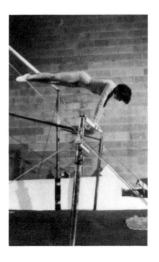
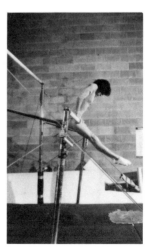

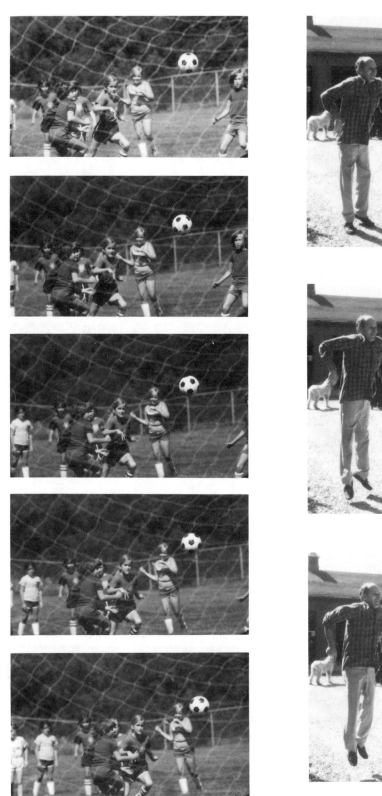

At ten frames a second on a high-speed Hulcher camera, that crucial soccer play is broken down into a frozen event in which the ball seems to hover.

At sixty-five frames a second, Hulcher's optimum speed, a short burst of a man jumping gives some twenty frames of him in the air from which to choose. Six are shown here, covering approximately one-eleventh of a second of the leap!

2

Lenses

It is the lenses—those beautiful objects of glass and metal—that will determine how good a sports photographer you become.

The ideal in all photos is sharpness. Your editors sit with those little five-to-eight power glasses and quickly eyeball your slides for sharpness first. Some editors even look for sharpness before they look for good exposures.

If your color slides are developed before you ship them to your client, be ruthless. Throw away all the bad exposures, especially those chalky whitish ones, and, without regret, throw away those unsharp products of these fantastic lenses.

DIAGRAM AND PICTURE
SEGMENTED INTO ANGLES

35mm Camera Lenses Focal Length mm	Angle of View (in degrees)
20	94°
24	84°
28	74°
35	62°
50	46°
85	28°30′
90	27°
105	23°20′
135	18°
180	13°40′
200	12°20′
300	8°10′
400	6°10′
500	5°
600	4°10′
800	3°
1000	2°30′

The modern camera lens from wide-angle through long telephoto is the sports photographer's means of covering an event. Here are ten pictures made from the same vantage point with different lenses, each with its own point of view.

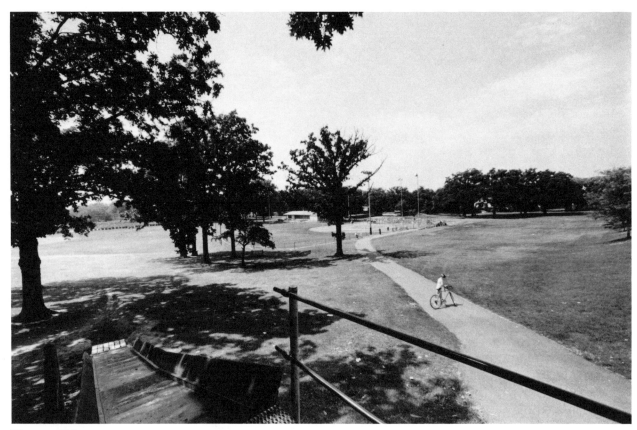

20mm 94°

28mm 74°

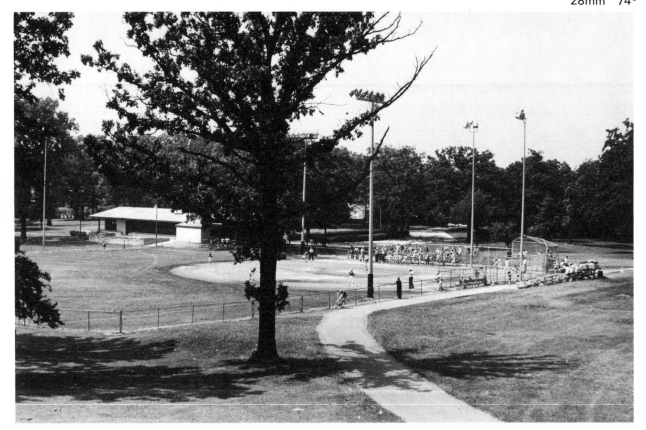

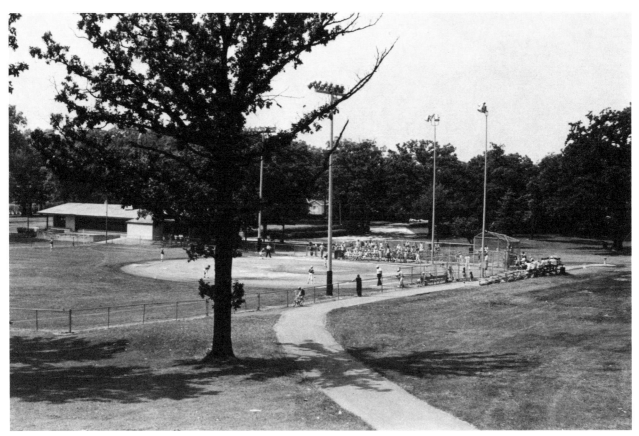

35mm 62°

50mm 46°

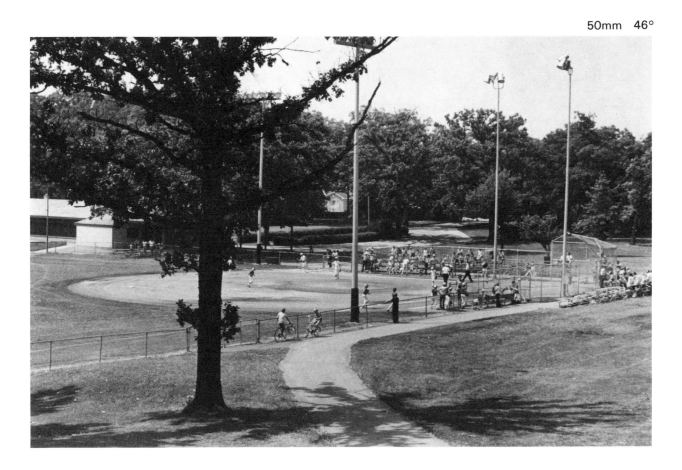

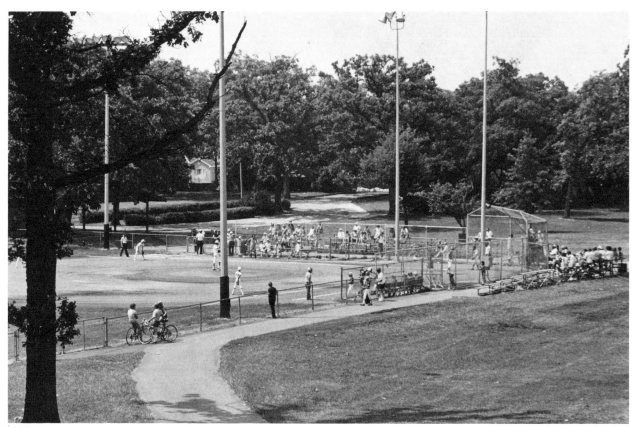

85mm 28°

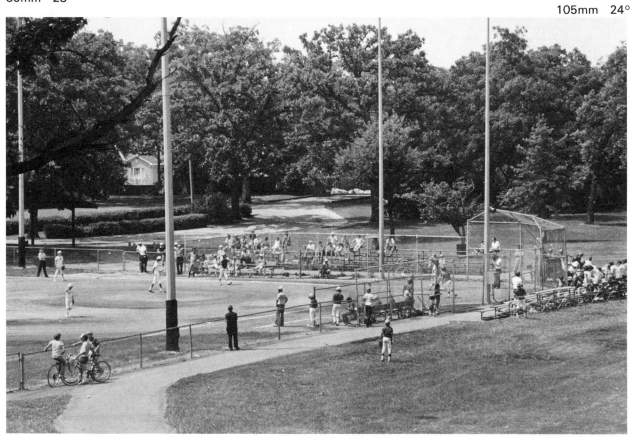

105mm 24°

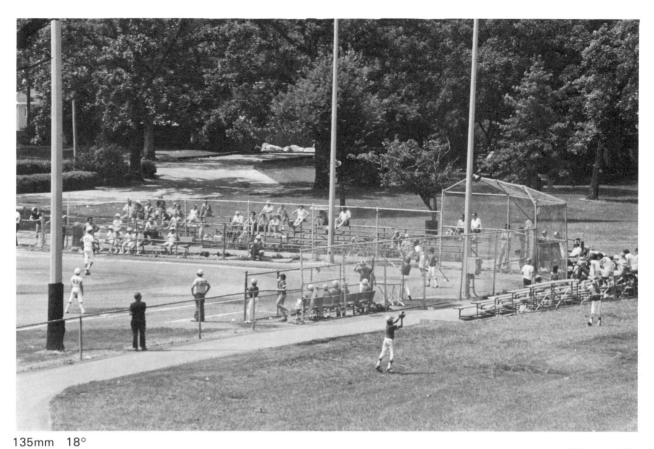

135mm 18°

200mm 12°

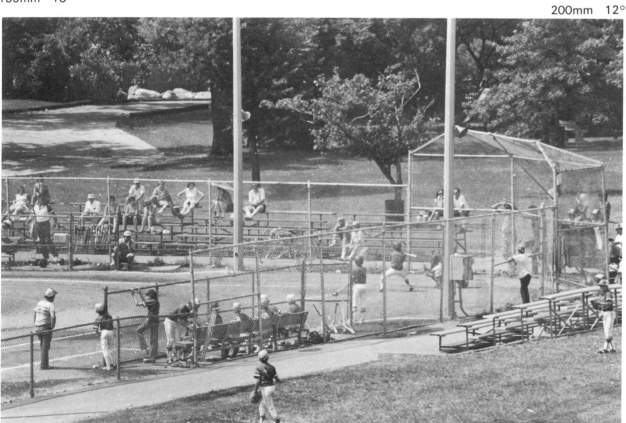

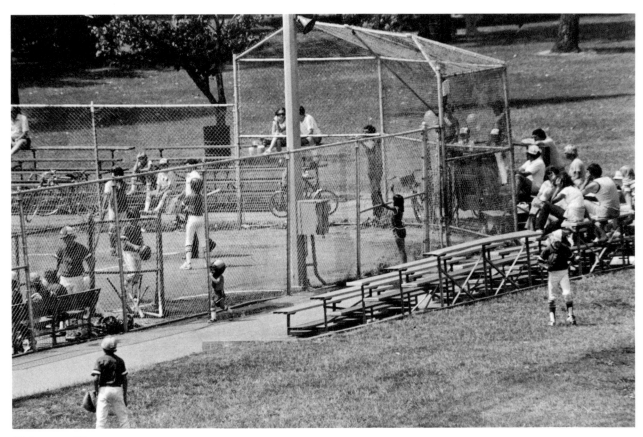

300mm 8°

400mm 6°

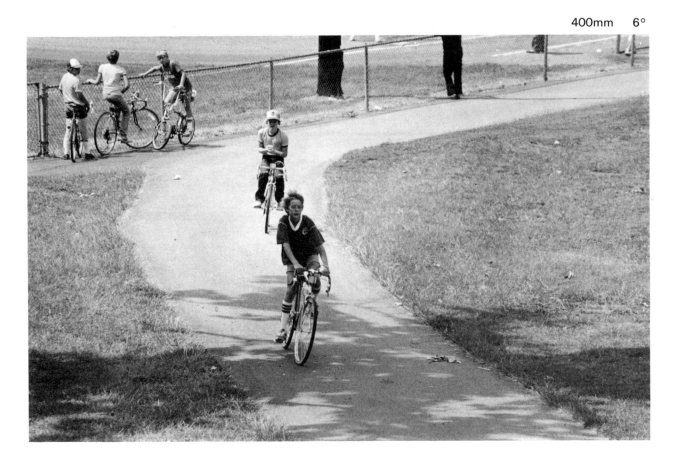

As you can see, the trick is to decide which angle of view you wish to cover, then pick the suitable lens. Much easier said than done.

There has been a recent explosion in lighter-weight, higher-quality lenses. The revolution has been led at the high-priced end of the scale by Nikon, with their magnificent ED series of telephotos; by Canon, with their rare glass telephotos up to 1000mm; by Olympus and Pentax, with their miniaturization of normal and wide-angle lenses. Vivitar, a huge lens manufacturer, makes a somewhat cheaper line of lenses that fits all the boxes listed above and more. There are also several companies, such as Tokina and Soligor, that make excellent cheaper line zoom lenses that do absolutely first-class work.

The 75–150mm and 80–200mm Tokina lenses used for some of the pictures in this book are as sharp as those produced by all the prime lenses, excluding the miraculous ED series.

If you look down the right angle made by, say, a book or a piece of paper, you can easily see what a 21mm lens sees. This is the kind of lens the sports photographer uses in tight places—in the locker room, for example. Care must be exerted with wide-angle lenses to keep the back of the camera parallel to the scene shot, to keep the corners of a room from "keystoning," or distorting.

The 24mm at 84 degrees and the 28mm at 74 degrees are good all-around lenses for the sports photographer to keep on a spare camera. One of these is perfect for shots on the sidelines, at halftime, at the end of the game or match, when the coach is lifted into the air. A longer lens, such as a normal 50mm would keep you too far back, and you would be shooting the heads of your competitors who were up front with their own wide-angles, rather than shooting the action.

You can set one of these lenses at eight feet and feel confident of getting acceptably sharp pictures from four feet to fifty feet at midscale apertures.

The 35mm is the feature photographer's friend. Its angle of 62 degrees is preferred by many photographers as a normal lens. It has more depth than the mathematically normal 50mm lens and is thus more forgiving in terms of focus.

The 85mm, 90mm, 100mm, and 105mm lenses are all fine portrait lenses for dynamic head shots. In the small court sports—handball, racquetball, squash, platform tennis—these lenses provide smashing close-ups of players in action.

Many of these 85–105mm lenses come in high-speed models. Canon makes a magnificent 85mm $f/1.2$ that is the favorite of gymnastics photographers. I like Nikon's 85mm $f/2$ for racquetball, but I also like a cheap Quantaray 135mm $f/1.9$ lens for those pictures of a player in deep court under a minimum of light.

The 180mm lens is a valuable tool for the sports photographer. Most manufacturers make one in $f/2.8$, which is suitable for gymnasium sports. Nikon makes an ED 200mm $f/2$ that is a magnificent lens for indoor track and field events. An attachment extender makes this a 400mm $f/4$ lens which is an achievement by itself. (Tele-extenders have also gone through a qualitative revolution. The extenders of a few years ago worked fine if you were merely using the center of the frame. The edges of the picture would go soft. The new generation of computer-hatched extenders provides a true doubling of the focal length along with a halving of the effective aperture—hence that 400mm at $f/4$.)

If you have to cover football, soccer, or baseball with but one lens—leaving zooms aside for the moment—your real friend is the 300mm.

That eight-degree field of view is just fine for end runs, batters if you're halfway down the sideline, and for joggers, pole vaulters, and the like. If your 300mm is fast enough—the fastest are now $f/2.8$ —an extender gives you a 600mm lens that's $f/5.6$. This is great for long soccer, football, or baseball views.

A 600mm lens will let you sit behind home plate and cover the outfield comfortably.

But the 400! Ah, the 400mm is a lovely lens. It is perfect for that play at second when you're shooting from a box along the third base line. You can shoot batters, quarterbacks, and other sports figures close up with the 400mm. Vivitar and Tokina make good, inexpensive 400mm lenses. Nikon's 400mm $f/3.5$ is expensive but absolutely state of the art at this writing. And Canon has just announced a

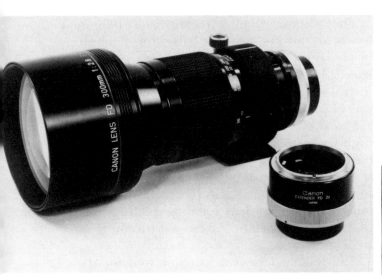

Canon's 300mm *f*/2.8 lens of a special fluorite glass guaranteeing super sharpness is shown with its companion tele-extender. This extender makes the lens a 600mm but costs two stops. So you have a 600mm, *f*/5.6 lens.

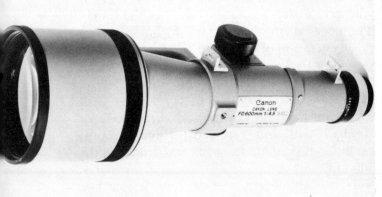

Canon is fighting Nikon's long hold on the sports photographer by producing long, light, sharp telephotos such as this 600mm *f*/4.5, which is fine for football, baseball, track and field, and other sports.

400mm *f*/2.8! The focal length and speed (as well as focusing by turning one small lens element) make it suitable for night sports. The light weight relative to the old blunderbusses available from Kilfitt in these focal lengths makes them valuable to fast-moving photographers.

The two-degree 1000mm lens is fine for nature pictures. For football it is capable of capturing a full length picture of a player

under one goalpost as viewed from under the other goalpost. I used this lens a lot for covering the Mafia for *Life*, but it is generally too heavy to take on location for the off chance that a great picture will occur a quarter mile away. Of course the new generation of mirror lenses, and catadioptrics, are much lighter.

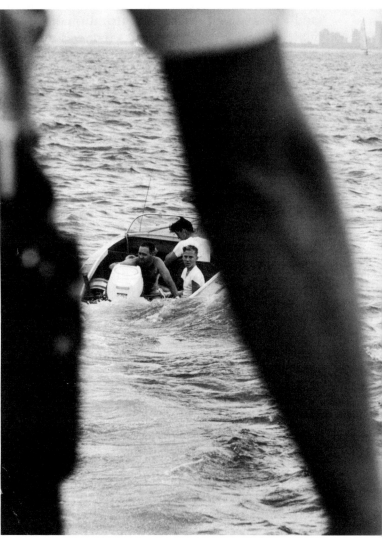

The long telephoto (400mm here) can sometimes distort the meaning of your picture or aid it. This photo was for a *Life* story on dangerous water practices and the rescue teams that help swamped boaters.

Several varieties of mirror lenses are now offered up to 1000mm. These are quite small for what they do, which is to bend the light rays back and forth and give you a sharp image at approximately *f*/8. Tokina and Soligor have recently made mirror lenses of 500mm that are no bigger than squared off

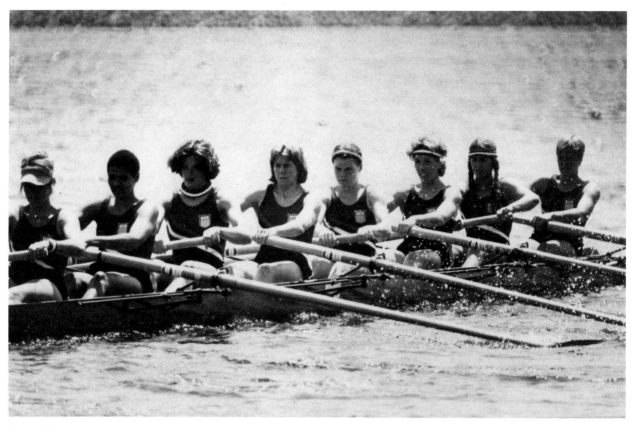

The U.S. Olympic women's crew was captured against the light with a 500mm telephoto mirror lens. Mirror lenses make interesting swirls of reflected light on the water.

baseballs. Mirror lenses are popular with boat photographers. Against the light they dapple the water surface with scalloped little circles that are pleasing the first few times you see them.

THE ZOOM LENSES

Just about every manufacturer makes an entire line of zooms, from wide-angle zooms (21mm to 35mm) to classic 43–86mm zooms (such as Nikon's); the 35–70mm zoom, made by several companies; Nikon's new 50–300mm ED zoom; the 80–200mm made by several manufacturers; the 180–600mm by Nikon; and Nikon's 360–1200mm $f/11$ lens.

Leitz makes 560mm lenses, and Spiratone, Tamron, and Soligor make many 500mm $f/8$s that are relatively cheap and acceptably sharp.

Tokina's 28–85mm and Fujinon's 29–47mm can be used on most single-lens reflexes.

The new computer-bred zooms constantly surprise the testers for *Modern Photography*

and *Popular Photography* magazines with their recent improvements in corner definitions. The computer has taken years off the process of lens design and lens manufacture. All the time-honored mathematical calculations are now done by computers, and somewhat more accurately in the curve area, too.

For the photographer, this means sharper zooms at lower prices. It will also mean the miniaturization of these and other lenses, as it already has.

Like the automobile companies, lens manufacturers aren't exactly sure which way their buyers are going to jump. Several years ago, when it became apparent that photographers of all kinds were buying the medium zoom lenses—80mm to 200mm or thereabouts—they assumed that professionals, especially sports photographers, would buy long zoom lenses—200–600mm, for example.

The first of these long single-collar (for focusing and zooming) lenses was the Nikon 200–600mm, which is an absolute joy when

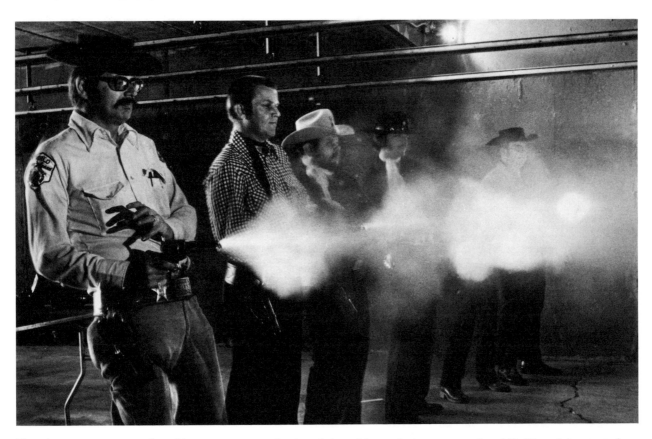

The shooters were caught with camera on a tripod and the wide-angle lens stopped to *f*/8. The trick was to keep the peripheral light down and to open the lens on bulb just before the shooters fired, and immediately close the lens, letting the gun flashes light them.
 The photographer must often act like a cheerleader and start the action on cue.

mounted on a tripod in a good grandstand seat over the heads of the linespersons.

The drawback to this lens is that its largest aperture is *f*/9.5, making it great for snow and water scenes where there is usually light to spare, but making it a little tough to do football in iron gray light or inside pictures under artificial light.

Nikon solved this by making an *f*/8 180–600mm zoom. Unfortunately, the last time I looked, this lens listed for $7,000! Tamron appeared with a fine *f*/6.9 200–500mm zoom for just under $1,000. Minolta weighed in with a 100–500mm *f*/8, price to be announced. Pentax came up with the most practical zoom of all—an *f*/6.7 135–600mm—for around $2,500.

Personally, I came to sports photography from a career as a *Life* photographer of crime stories—some fifty Mafia stakeouts with long lenses. It was these long lenses that got me into sports photography when *Sports Illustrated* magazine came along.

Thus, I have a fine 200–600mm *f*/9.5 Nikon zoom that I bought used for $400 in 1978, and a superb 50–300mm Nikon *f*/4.5 zoom that becomes a 100–600mm *f*/8 zoom when used with an extender accessory lens.

Still, that *f*/6.7 Pentax makes my acquisitory gland water, because any long lens of high quality that is faster than *f*/8 is useful for sports. A good technician can generally adapt any long lens to any other box, possibly losing the automatic stopping-down feature.

Would-be sports photographers who come to me for advice on buying zooms usually go away with my personal prejudices.

Most amateurs have a single-lens reflex box with at least one lens—usually a 50mm normal lens.

For sports, my suggestion is that the photographer buy the zoom lens made by his or her camera's manufacturer that comes closest to 80–200mm.

If there is a budget problem, as there often is, my second choice would be a Tokina zoom;

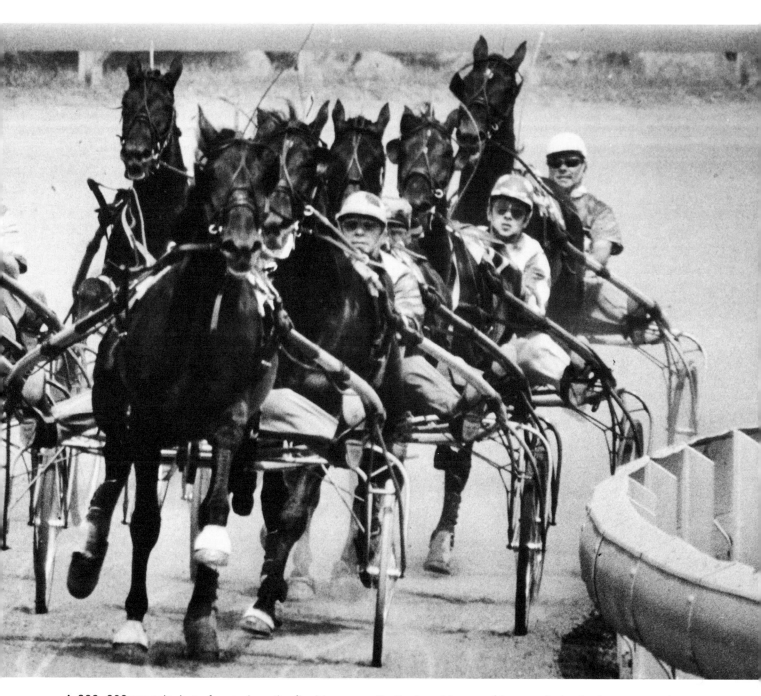

A 200–600mm telephoto focused on the final turn permits the bunching up of horses. A shorter lens or zooming-down set for the finish line permits you to cover both the turn and the finish. Most sports photographers use assistants to operate cameras from various parts of the tracks to cover a crucial race. Note the limited focus of the long focal length.

third choice would be Vivitar, Kiron, or Tamron; my fourth choice would be a Soligor.

There are some 80–250mm zooms that should be examined and tested if the lens hefts well in your hand. Test it by shooting at infinity, across a cityscape of tall buildings, signs, bridges—almost any view that fills the corners of a frame. If the corners don't seem to

fall off too much and you can read letters clearly with the lens wide open, the chances are that you have a good lens.

There are 90–230mm lenses that are fairly expensive. I have tested several Asanuma lenses and find them to be excellent. In many cases they are as good as the top-name lenses.

Remember to use a tripod if at all possible

with a long zoom lens, expecially if you use your zoom with an optical extender, which you should do if you want to specialize in sports.

You will lose two stops, but just sitting there with, say, an 80–200mm $f/3.5$ lens and extender gives you a 160–400mm lens a hair under $f/8$. This permits you to shoot Kodachrome 64 at 1/250 when bright subjects are moving around in good light, such as swimmers. With black-and-white film at ASA 400, you can shoot at 1/500 at $f/16$ in sunlight and 1/500 at $f/8$–11 against the light, as a rule of thumb. Kiron and several others are marketing an extender that only gives you a lens of half again your focal length. Instead of costing you two stops, it costs you one. Thus, a 200mm at $f/4$ becomes a 300mm at $f/5.6$.

The factor working for the sports photographer who gets used to zooms is that the central area of a well-focused zoom picture is often indistinguishable from that taken with a prime lens of similar focal lengths.

When you are shooting against the light and it is harder to avoid flare coming into the lens with the sun or other close, brilliant light, you do pay a price but the advantages outweigh the negative aspects: You are able to frame at your eye's discretion. You can zap in on details such as facial expressions. You can also retain a great deal of apparent mobility while seated in one position—for instance, behind a baseball dugout or in one of the boxes along the first or third base lines that ball clubs generally assign to photographers—during a noncrucial game.

3
Films

Most magazine pictures, especially sports pictures, are exposed on slide films. These are called reversal films. Kodak makes almost all of the best ones.

Each film has a code number that appears along the edge of the film at varying intervals. These films and code numbers are:

5036　Kodak Ektachrome Professional Film Daylight
5076　Kodak Ektachrome 200 Film Daylight
5073　Kodachrome 25 Film Daylight
7267　Kodachrome 25 Movie Film Daylight
5017　Kodak Ektachrome 64 Professional Film Daylight
5031　Kodak Ektachrome 64 Film Daylight
5032　Kodachrome 64 Film Daylight
5074　Kodak Ektachrome 400 Film Daylight

KODACHROME

Kodachrome 25 (ASA) is extremely fine-grained and suitable for enormous enlargements. Its slowness limits it somewhat for high-speed action shots, except at wide aper-

tures or on ski slopes and on beaches or at sea where reflective surfaces add to the available light, permitting fast shutter speeds. This film, like the slightly grainier but still magnificent Kodachrome 64, has a built-in exposure latitude of 2½ stops. That means you can goof the exposure a stop and a half on the over side or a stop and a half on the under side and still get a usable transparency!

These films have the advantage of being developed by Kodak at one of its processing plants. (Although a few labs are undertaking the complicated business of processing Kodachrome themselves now—even pushing it a couple of stops.) Kodak's magnificent processing, on expedited service, available through your local dealer, can have your film back to you in one day—except around a holiday or when they really get backed up.

EKTACHROME

Next come the Ektachromes. Ektachrome 64 for daylight exposures has about the same exposure leeway as Kodachrome. Color differences between this Ektachrome and Kodachrome are minuscule. A good color lab can

25

return your Ektachromes in an hour and a half.

Ektachrome 200 Daylight is somewhat grainier than the slower Kodachromes and Ektachromes, but it is still a fine film for sports photography. Many a two-page color shot has been made with this film.

Ektachrome 160 Tungsten for exposure under tungsten light is discussed later. Just read the instructions, which include the actual film speed of the batch you've bought in small red letters. It could be ASA 125 or ASA 200!

Ektachrome 400 is Kodak's newest film, and it is acceptably exposed a full stop over or a full stop under. (If you're shooting color for publication, keep your color just a hair—a third of a stop—under, and your engraver will thank you.)

AGFACHROME

A European film, Agfachrome 64, may require some investigation for developing in this country, but it is good film and gives a leeway in exposure of around three stops.

FUJICHROME

A Japanese company, Fuji, makes Fujichrome, rated at 100, which can be developed in Ektachrome's chemistry. Its effective speed seems to be around ASA 160, a half stop higher than its rating of 100.

KODACOLOR 100, VERICOLOR 100, KODACOLOR 400

For prints—that is, if you want to end up with prints—Kodak makes three fantastic negative color films: Kodacolor 100, Vericolor 100, and Kodacolor 400.

The 100-speed films are even finer-grained than the Kodachromes and can be enlarged to mural size without showing grain. The new Kodacolor 400 performs well under almost every kind of light without filters. It is somewhat grainier than the slower films and definitely should not be pushed unless you want lots of grain for some aesthetic reason.

It is possible to save money by bulk-loading color film into cartridges sold at camera stores. This kind of loading does indeed save money because the film can be bought in 100-foot rolls. But there is some risk of fingerprints and scratching, plus the inconvenience of having to load the film in a darkroom.

At any rate, if you are at all interested in sports photography, don't load up with 20-exposure loads. Get the 36-exposure rolls. They're much cheaper in the long run, and if you're to be a sports photographer, you must get used to shooting lots and lots of film.

A new development in film!

Ilford, the English film manufacturer that used to make a 35mm plastic box for its film that was difficult to open in cold weather (the plastic snap would break off), has now redeemed itself. Ilford has just marketed its fine HP5 film—the equivalent of Kodak's dependable ASA 400 Tri-X—*in 72-exposure loads*. Some say it's even superior to Kodak's film. Ilford achieved this by using thinner-based film. The film presents a frame counting problem with most cameras, which cut off at 36, but most cameras will go on shooting. You just won't be able to keep an accurate count of the final 36 pictures. Watch the photo magazines for tests of new films, black and white and color. You will come away with great respect for the latitude and forgiving qualities of modern film.

On the plus side, if you tend to zap through lots of film with your motor drive, you can just reset the motor drive's film counter—and you have the advantage of the double loading. On the debit side again, nobody yet makes a 72-exposure tank. It shouldn't be long before this is corrected. This thin-based film gives the 250-exposure Nikons, Canons, and Olympuses double their capacity to 500 exposures per cartridge—a quantum leap!

It is wise to study the instruction sheet that comes with each roll of film. Kodak tests each batch of film it manufactures, and in the interest of honesty and precision, the company prints in tiny red letters the phrase: Effective Speed: ASA 160. This informs you that you should set your meter a little lower, because this batch of film is a bit slower than the rated ASA 200. Magazine photographers have lost important pictures by not allowing for this.

For example, when you push ASA 200 film two stops, you want ASA 800. If the film's effective speed is only 160, pushing two stops give you only 640—nearly a full stop off!

If the film says, Effective Speed: ASA 50, it is about 15 percent lower than the ASA 64 you thought you were getting, which could be crucial in critical color balance situations. The moral is: Check the insert sheet! Use Kodak's fine directions!

Kodak is one of the most explicitly helpful of all American film manufacturers. The firm publishes tons of material designed to help photographers take better pictures. Again, when all else fails, the best advice one can give is, "Read the directions."

The film directions for black and white and color are absolutely comforting to the relatively inexperienced photographer. They will give you something to compare to your sophisticated camera's automatic readings.

Here are several sets of directions:

KODACHROME 25 Film (Daylight)
FOR COLOR SLIDES
135 MAGAZINES 5073

 DAYLIGHT PICTURES

FOR AUTOMATIC CAMERAS OR EXPOSURE METERS
Set film-speed dial on camera or exposure meter at ASA 25.

SETTING CAMERAS WITHOUT AN EXPOSURE METER
Use the exposure indicated below under the appropriate lighting condition.

DAYLIGHT EXPOSURE TABLE FOR *KODACHROME 25 FILM*				
Shutter Speed 1/125 Second			Shutter Speed 1/60 Second	
Bright or Hazy Sun on Light Sand or Snow	Bright or Hazy Sun (Distinct Shadows)	Cloudy Bright (No Shadows)	Heavy Overcast	Open Shade†
f/11	f/8*	f/4	f/4	f/4

*f/4 at 1/125 second for backlighted close-up subjects.
†Subject shaded from the sun but lighted by a large area of sky.

KODACHROME 64 Film (Daylight)
FOR COLOR SLIDES 135 MAGAZINES
Use in DAYLIGHT or with BLUE FLASH

 DAYLIGHT PICTURES

AUTOMATIC CAMERAS OR EXPOSURE METERS
Set the film-speed dial on your camera or exposure meter at ASA 64 for proper exposure of this film.

SETTING CAMERAS WITHOUT AN EXPOSURE METER

DAYLIGHT EXPOSURES—*KODACHROME 64 FILM*				
Shutter Speed 1/125 Second				
Bright or Hazy Sun on Light Sand or Snow	Bright or Hazy Sun (Distinct Shadows)	Cloudy Bright (No Shadows)	Heavy Overcast	Open Shade†
f/16	f/11*	f/5.6	f/4	f/4

*f/5.6 at 1/125 second for backlighted close-up subjects.
†Subject shaded from the sun but lighted by a large area of sky.

For exposure Ektachrome 64, use Kodachrome 64 directions.

KODAK TRI-X PAN FILM
IN ROLLS AND 135 MAGAZINES
FILM SPEED ASA 400

This high-speed, fine-grain film with very high sharpness is especially useful for dimly lighted subjects and fast action, for extending the distance range for flash pictures, and for photographing subjects requiring good depth of field and high shutter speeds. Use this film in cameras with adjustable shutter speeds and lens openings.

Handling: Load and unload your camera in subdued light. After the last exposure and before opening the camera, rewind 135 film into its magazine.

DAYLIGHT PICTURES ● Set your exposure meter or automatic camera at **ASA 400**. If negatives are consistently too light, increase exposure by using a lower film-speed number; if too dark, reduce exposure by using a higher number.

If you don't have a meter or an automatic camera, use the exposures for the appropriate lighting conditions in the table below.

DAYLIGHT EXPOSURE TABLE FOR *KODAK TRI-X PAN FILM*				
Shutter Speed 1/500 Second	Shutter Speed 1/250 Second			
Bright or Hazy Sun on Light Sand or Snow	Bright or Hazy Sun (Distinct Shadows)	Cloudy Bright (No Shadows)	Heavy Overcast	Open Shade†
f/22	f/22*	f/11	f/8	f/8

*f/11 at 1/250 second for backlighted close-up subjects.
†Subject shaded from the sun but lighted by a large area of sky.

KODAK EKTACHROME 160 Professional Film (Tungsten)

Process E-6

● The following information, determined at the time of manufacture, applies to film packaged herein.

EFFECTIVE SPEED: ISO 200 (24°)/ASA 200 (24 DIN)

The following information, based on average emulsions, is to determine speed under various light sources:

LIGHT SOURCE	SPEED	WITH FILTER SUCH AS:
Tungsten (3200 K)	ISO 160 (23°)/ASA 160 (23 DIN)	None
Photolamp (3400 K)	ISO 125 (22°)/ASA 125 (22 DIN)	Kodak Filter, No. 81A
Daylight	ISO 100 (21°)/ASA 100 (21 DIN)	Kodak Filter, No. 85B

For critical use, a color compensating filter may be needed even at normal exposure conditions.

On top of the Ektachrome direction sheets (back page) is the following notation: Effective Speed: ASAxxx. No matter what the outer package says—use this effective speed number. It represents Kodak's careful test of each batch of Ektachrome.

KODAK EKTACHROME 200 Film
(Daylight) For Color Slides
135 MAGAZINES 5076 FILM SPEED ASA 200

USE IN DAYLIGHT OR WITH BLUE FLASH

This new high-speed film has improved grain characteristics and color rendition, resulting in higher-quality slides. The high speed makes it ideal for dimly lighted subjects, for fast action, for extending the distance range for flash pictures, and for subjects requiring good depth of field and high shutter speeds. By obtaining special processing, you can expose the film at ASA 400. See the "Processing" section on the back of this sheet.

Handling and Storage: Load and unload your camera in subdued light. Have the film processed promptly after exposure. Store film and slides in a cool, dry place.

 DAYLIGHT PICTURES (at ASA 200)

Exposure Meters or Cameras with Exposure Meters: Set the film-speed dial on your exposure meter or camera at **ASA 200.**

Note: With cameras that do not have a focal-plane shutter, you must use a smaller lens opening than the meter indicates when conditions require high shutter speeds and medium or small lens openings. See footnote in table below.

Setting Cameras Without Exposure Meters:

DAYLIGHT EXPOSURES—Ektachrome 200 Film (Daylight)				
Set Shutter Speed at 1/250 Second Exposure Settings Are for Focal-Plane Shutters*				
Bright or Hazy Sun on Light Sand or Snow	Bright or Hazy Sun (Distinct Shadows)	Cloudy Bright (No Shadows)	Heavy Overcast	Open Shade‡
f/22	f/16†	f/8	f/5.6	f/5.6

*When using a camera with a leaf-type shutter under lighting conditions that require high shutter speeds and medium or small lens openings (lens openings beginning about midway on your camera's lens-opening scale), reduce exposure as follows: at 1/250 second, use a lens opening ½ stop smaller than indicated; at 1/500 second, use a lens opening 1 stop smaller than indicated.
†f/8 at 1/250 second for backlighted close-up subjects.
‡Subject shaded from the sun but lighted by a large area of sky.

KODAK EKTACHROME 400 Film
(Daylight) For Color Slides
IN ROLLS AND 135 MAGAZINES FILM SPEED ASA 400

This very high speed color-slide film is color-balanced for daylight, blue flash, and electronic flash. It is an excellent choice for dimly lighted subjects, for fast action, for extending the distance range for flash pictures, and for subjects requiring good depth of field and high shutter speeds. By obtaining special processing, you can expose the film at ASA 800. See the Processing section.

For maximum speed in low-light conditions, you can expose this film without a light-balancing filter. This will produce a warm or yellow-red result under tungsten lighting, such as household light bulbs, and slightly greenish results under most fluorescent lamps, but you may find it quite acceptable.

Handling and Storage: Load and unload your camera in subdued light. Have the film processed promptly after exposure. Store film and slides in a cool, dry place.

DAYLIGHT PICTURES (at ASA 400)

Exposure Meters or Cameras with Exposure Meters: Set the film-speed dial on your exposure meter or camera at **ASA 400.**

Note: With cameras that do not have a focal-plane shutter, you must use a smaller lens opening than the meter indicates when conditions require high shutter speeds and medium or small lens openings. See footnote in table below.

Setting Cameras Without Exposure Meters:

DAYLIGHT EXPOSURES—Ektachrome 400 Film (Daylight) Exposure Settings Are for Focal-Plane Shutters*				
Shutter Speed 1/1000 Second	Shutter Speed 1/500 Second			
Bright or Hazy Sun on Light Sand or Snow	Bright or Hazy Sun (Distinct Shadows)	Cloudy Bright (No Shadows)	Heavy Overcast	Open Shade‡
f/16	f/16†	f/8	f/5.6	f/5.6

*When using a camera with a leaf-type shutter under lighting conditions that require high shutter speeds and medium or small lens openings (lens openings beginning about midway on your camera's lens-opening scale), reduce exposure as follows: at 1/250 second, use a lens opening ½ stop smaller than indicated; at 1/500 second, use a lens opening 1 stop smaller than indicated.
†f/8 at 1/500 second for backlighted close-up subjects.
‡Subject shaded from the sun but lighted by a large area of sky.

Kodacolor II FILM

FOR COLOR PRINTS AND ENLARGEMENTS
Use in DAYLIGHT or with BLUE FLASH. FILM SPEED ASA 100

 DAYLIGHT PICTURES

AUTOMATIC CAMERAS OR EXPOSURE METERS
Set film-speed dial on camera or exposure meter at ASA 100.

SETTING CAMERAS WITHOUT AN EXPOSURE METER
Use exposure indicated for appropriate lighting condition.

DAYLIGHT EXPOSURE TABLE FOR KODACOLOR II FILM				
Shutter Speed 1/125 Second				
Bright or Hazy Sun on Light Sand or Snow	Bright or Hazy Sun (Distinct Shadows)	Cloudy Bright (No Shadows)	Heavy Overcast	Open Shade†
f/16	f/11*	f/5.6	f/4	f/4

*f/5.6 at 1/125 second for backlighted close-up subjects.
†Subject shaded from the sun but lighted by a large area of sky.

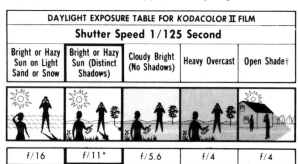

4

Exposure

One of the best sports photographers in the world is Neil Leifer, a man with a thousand pages of sports color pictures behind him. He once waved nervously to me from the sidelines of a college football game. "Hey Art," he called, pointing his exposure meter up, down, and sideways, "what kind of exposure are you getting?"

No single aspect of sports photography gives photographers more trouble than determining the correct exposure—that combination of lens opening and shutter speed that will result in a perfect slide or negative. Whether you determine your own exposure through a series of educated guesses, let your state-of-the-art reflex camera set itself, or use an external exposure meter, the chances are that you won't feel 100 percent confident that your camera is set right until you see the results. The changing light asks you, your camera, or your meter to make a series of judgment calls, as they say in the world of sports. Before passing on a few simple tricks of the trade that will help you feel more confi-

dent in your educated guesses, let's examine the components of good exposure.

SHUTTER SPEED

There are two principal types of camera shutters. Most modern single-lens reflexes employ a focal plane shutter, a cleverly designed series of cloth or metal window shades that snap open and shut at precise intervals chosen by the photographer. These intervals are called shutter speeds and are usually controlled by a little knob or ring at the top of the camera or on the lens itself.

A few 35mm single-lens reflex cameras utilize leaf shutters. These are a series of very thin overlapping metal wafers that open and close for various intervals. These intervals are set by the photographer or by a built-in automatic meter that measures the light and keeps the shutter open as long as is necessary to get what appears to the meter device to be perfect exposure.

Modern shutter speed dials are marked as follows:

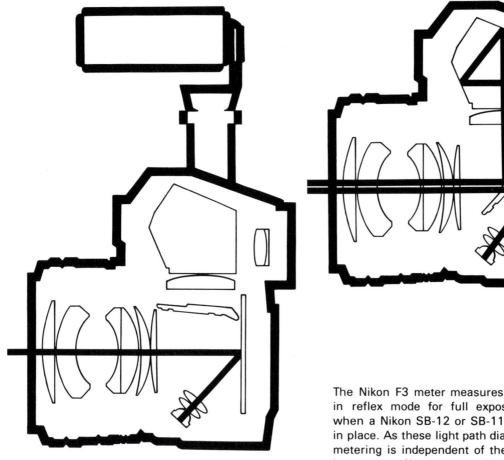

The Nikon F3 meter measures light through the lens, in reflex mode for full exposure automation, even when a Nikon SB-12 or SB-11 Thyristor Flash Unit is in place. As these light path diagrams illustrate, the F3 metering is independent of the viewfinder and focusing screen. No compensation is needed, no matter what combination of finder, screen, and lens or accessory is used.

B T 1 2 4 8 15
30 60 125 250 500 1000 2000

The **B** stands for the old-time photographer's bulb, which was a little rubber ball that actually functioned as an air syringe. The photographer squeezed the bulb, forcing air through a slender rubber hose to a shutter that responded to the rush of air from the bulb. The first squeeze would open the shutter and the second would shut it, with the photographer controlling the length of time during which the light came through the lens and piled up on the film.

Obviously, the bulb exposure was used primarily for stationary objects, with the camera on a tripod.

The process described above is, of course, the way bulb exposure works today as well.

When time and subject are no problem, bulb exposure is still an important tool for the modern photographer.

The T stands for time. Pressing the shutter release button with the lens set on T opens the lens and permits it to stay open until the shutter release button or a cable release screwed into the shutter is pushed again.

In general, bulb is used for short exposures (up to a count of thirty seconds). Beyond thirty seconds, especially in cold weather, it is much more prudent to use T—pressing the shutter, putting your hands in your pockets, and timing your exposure either by counting to yourself, "a thousand and one, a thousand and two . . ." or by consulting your wristwatch.

The amateur photographer is likely to be needlessly terrified of the bulb and time exposures, making them two of the least frequently

used settings on the camera. Here are a few exposure tips to offset such fears.

Use a tripod or other solid support. Some photographers who don't like to carry a full-sized tripod carry a folding miniature tripod with some sort of ball socket head. This tripod is then used at ground level or placed on a ledge, table, or other handy stanchion.

As a rule of thumb, set the lens about a third of the way down the lens scale; *f*/4 and *f*/5.6 are good, friendly lens apertures for this kind of work.

Don't be afraid to experiment with various exposures during a bulb or time exposure. Start with one second. Then try several at two seconds, three seconds, and so on. If your automatic superdeluxe camera meter turns itself off after deciding to stay open for five seconds, set your camera on bulb and try a couple of exposures at three, four, six, seven, and eight seconds. Of course, this involves a decision on your part: is the picture worth more than one frame? Generally, unless you are on a near-starvation film diet, you should never shoot fewer than two frames of anything worth shooting from a tripod. You will never be sorry to have a slightly different exposure that will give you a finer shot than the orthodox, automated one. In addition, if there is a scratch or a little water bubble on the slide or negative, you will have a spare.

The opportunities for long, slow exposures are limited in sports photography. Fireworks set off after the ball game are easy to shoot from the tripod, for example. Statues, interiors, and the like are also good T and B subjects.

However, the basic targets of sports photographers are extremely active people and animals or both. These subjects require a good working knowledge of all those other numbers on the shutter speed dial. These numbers—1, 2, 4, 8, 15, 30, 60, 125, 250, 500, 1000, and, in the more expensive cameras, 2000—are merely one second divided into fractions, as follows:

1 = 1 second
2 = 1/2 second
4 = 1/4 second
8 = 1/8 second
15 = 1/15 second
30 = 1/30 second
60 = 1/60 second
125 = 1/125 second
250 = 1/250 second
500 = 1/500 second
1000 = 1/1000 second
2000 = 1/2000 second

It doesn't take a mathematical or photographic genius to see that each shutter speed on the dial is twice the duration of the one that comes after it. The 1-second setting will let in twice as much light as the 1/2-second setting, and so on down the line. In practical terms, this allows you to cut your shutter speed in half each time you move down the dial. It sounds much more complicated than it is. Your shutter can provide any exposure time you need, from a full second to one of two thousandths of a second. The bulb and time settings expand this capability to an infinite amount of additional time.

The photographer must select a shutter speed that is capable of freezing the action he or she hopes to shoot. (Deciding to blur the subject rather than stop it is also a shutter speed decision.)

Those active humans and animals encountered in sports photography can be stopped in their tracks perhaps 75 percent of the time by a basic shutter speed of 1/250 second. The chart below shows that stopping action depends on the angle your moving subject makes across your field of view. A horse racing left to right across your picture might require 1/500 second to stop the action. The same horse, running toward you, might be rendered sharply on film with a shutter speed of 1/125 second. Each of these shutter speeds, of course, will require a different lens aperture (discussed later in this chapter).

The sophisticated automatic cameras that have built-in exposure computers make instantaneous and continuous readings of the scene in front of them. The photographer chooses a shutter speed that is capable of stopping the action; the camera's photoelectric sensing system opens the lens to precisely the correct aperture for that shutter speed. Other equally sophisticated cameras permit you to choose your lens opening (aperture) first. The camera then sets the shutter speed. A precision

Shutter Speeds for Various Types of Action Pictures
(normal lens)

Subject	Speed	Distance from Action to Camera	Angle of Action Moving Toward or Away from Camera		
			Coming at You or Retreating	45 Degrees	Right Angle (Coming Past You)
Slow-Moving	(3 to 15 mph)	Up to			
Children,		15 feet	1/250	1/500	1/500–1/1000
animals,		30 feet	1/125	1/250	1/500
joggers,		60 feet	1/60	1/125	1/250
boats		150 feet	1/60	1/125	1/250
Faster-Moving	(15 to 35 mph)	Up to			
Runners, kids		15 feet	1/500	1/500–1/1000	1/1000
at play, basketball,		30 feet	1/250	1/500	1/1000
track events,		60 feet	1/250	1/500	1/1000
racehorses		150 feet	1/250	1/500	1/1000
High-Speed Action	(35 mph and up)	Up to			
Racing bikes,		15 feet	1/1000–1/2000	1/1000–1/2000	1/1000–1/2000
cars, boats, etc.		30 feet	1/500	1/1000	1/1000–1/2000
		60 feet	1/500	1/1000	1/1000–1/2000
		150 feet	1/500	1/1000	1/500 –1/1000

Panning the camera at a brave 1/30 second (with lens stopped accordingly to f/22) resulted in this picture of a 100-meter sprint start.

oscilloscope measuring the shutter's open time during this kind of exposure might read "1/233 second" or "1/278 second."

If your camera isn't that sophisticated, that good old 1/250 second (which may be a little high or a little low because of the imprecision of mechanical things that contain springs) will work fine for many action pictures. If you learn how to swing your camera along with the action, you can stop even more of the sports action you're after. Camera shutters, lenses, and films, fortunately, are quite forgiving. It would take a sharp-eyed lab technician, editor, or densitometer to discern the difference between an exposure made at 1/233 second and one made at 1/278 second. Most films have enough latitude to allow for considerable variation in exposure—usually up to 3 exposure stops, 1½ stops on the under side and the same on the over side.

The shutter is literally a curtain that lets a precise amount of light through the lens onto the film. It is responsible for stopping action

and is therefore a valuable ally of the sports photographer. As exactly half the variable components in photographic exposure, the shutter setting should be the sports photographer's first consideration in exposure.

LENS OPENING

Now that one of the important variables in your exposure has been dealt with, and you can range the shutter dial of your camera, halving and doubling the speeds according to the action you wish to photograph, you must set your lens opening properly.

Like the shutter, the lens is a means of getting a predetermined amount of light onto your film.

A combination of shutter speed and lens opening that permits too much light to hit the film will give you overexposed pictures. In color these are washed-out slides with terrible color. Faces look chalky-pale; you've wasted film and time. Even a good lab can't salvage overexposed slides.

Underexposed color shots are merely dark, dark, dark. Holding them up to a lit tungsten bulb, you may be able to discern some of your lost scene or subject. A good lab can sometimes salvage an underexposed slide by contact printing it onto a special film. Allowing for the original error, the lab might come up with a fairly acceptable duplicate.

It's far better—and much easier—to learn to expose properly.

Most modern lenses are amazingly sharp. Their ability to reproduce a scene is almost miraculous. The modern computer is responsible for a quantum leap in lens design. Mathematical lens formulae used to take years and years to work out manually. Computers now do the job in days. New optical glass and procedures have contributed to the general excellence of even the cheaper lines of lenses.

Whereas the camera shutter, whether focal plane or leaf type, doesn't have a synonym— the lens opening has many.

Lens openings are also known as *f*-stops, lens stops, apertures, aperture-stops, aperture-openings, diaphragm stops, *f* openings, and *f* numbers. Some ancient lenses adapted by mechanical geniuses with a lathe to work on modern camera bodies are adjusted by a series of *waterhouse stops,* holes drilled in a rotating disc that turns on a little shaft so that various-sized holes allow succeedingly smaller or larger amounts of light to pass through the lens.

Some cameras and exposure meters are calibrated in EVS or LVS settings. EVS stands for Exposure Value System. LVS stands for Light Value System. These European systems, later incorporated into many Japanese cameras, have never become popular in this country. The idea behind the EVS and LVS systems was to narrow the entire exposure to a single number that would stand for a combination of lens opening and shutter speed.

Moving one or two dials would permit you to set your camera with any of the equal-exposure settings. The trouble with this system, aside from its current obsolescence in the face of computers under the hoods of most first-line cameras these days, is that if you somehow set the wrong exposure into the LVS system, all your other exposures would also be wrong. Also, some of the cameras overdesigned this faculty, making it very difficult to disengage the system and go back to simple intelligent setting of lens and shutter separately.

Lenses are calibrated in *stops,* markings that are a ratio of the lens diameter to its focal length. For practical purposes the sports photographer must pay attention to the *f*-stops on a lens.

Generally, the bigger the front surface of a lens, the more light it lets in. The fastest lens that is generally used on most 35mm single-lens reflex cameras is $f/1.4$. The speed of a lens is referred to by its highest f number, as in an $f/1.4$ lens, an $f/1.8$ lens, or an $f/2$ lens. The $f/1.4$ lens is generally marked in the following manner:

$$1.4 \quad 2 \quad 2.8 \quad 4 \quad 5.6 \quad 8 \quad 11 \quad 16$$

Each succeeding stop lets in half as much light as the preceding stop. That is, $f/1.4$ lets in the most light; $f/2$ lets in half as much; $f/2.8$ lets in half as much as $f/2$; $f/4$ lets in half as much light as $f/2.8$, and so on.

Why choose one *f*-stop over another?

Without getting into complicated optical theory, you can look through your single-lens reflex camera at a bookcase forty-five degrees from you and learn a lot about lens apertures.

With your normal lens wide open—at *f*/1.4 or *f*/1.8—look at a book about five feet down the bookcase. Focus on the title. Then stop the lens at *f*/4 and look through the camera again with your finger on the *stop down* button or *pre-view* switch common to most modern cameras. With your lens wide open at *f*/1.4, the book title, along with one or two books on either side of that book, appeared to be sharp. At *f*/4, your field will appear a little darker, but you should be able to see a couple of additional books more sharply on either side of the book on which you focused. At *f*/16, the image of all the books may be quite dark. However, you should be able to make out most of the titles from the very beginning of your viewing screen past the book on which you are focusing, and the sharpness continues down the line.

Stopping down, then, gives you a deeper area of sharpness than you had before you stopped down. More objects in your picture will be in focus, not just the plane you focused on at *f*/1.4. Naturally, there will be many times when you won't *want* a great deal of depth—for instance, when you are using a telephoto lens to focus on one special performer or family member.

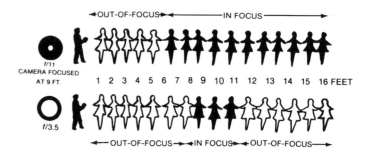

EXPOSURE TIPS

One of the wonderful things about photography is that it allows the photographer all sorts of latitude. An exposure on Kodachrome or Ektachrome 64 ASA of 1/125 second at *f*/8

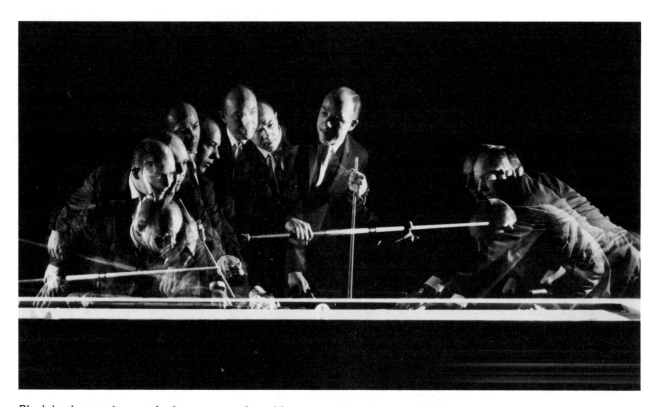

Black backgrounds must be hung to permit multiexposures in which the background doesn't shine through.

will provide a fine, well-exposed picture for an average scene in which sunlight sifts through a few clouds, and patches of tree shadows, house shadows, or stadium shadows appear in the background or foreground.

The same quality of exposure—the same slide or negative density—is also possible by exposing at 1/60 at $f/11$, 1/250 at $f/5.6$, 1/500 at $f/4$, 1/1000 at $f/2.8$, and so on. Here, of course, we're talking about good, basic, normal exposure—not depth of field.

At $f/16$, recalling the bookcase seen through the lens of the single-lens reflex, more of your picture will be sharp from the front of the picture toward infinity at $f/16$ than at $f/2.8$. If you expose a 1/125 $f/8$ scene at $f/11$ or $f/5.6$, the chances are your picture will still be acceptable.

Many lenses have guide marks on them that permit you to choose the kind of depth of field you wish, by picking one aperture over another. Of course, your choice of shutter speed necessary to stop the action you're shooting will influence how far you can stop your lens down in pursuit of depth.

A good rule of thumb in the use of lenses—expecially normal and wide-angle lenses—is to set your focus at one-third of the way into a general scene, such as kids frolicking in a big backyard, and then concentrate on your shutter speed and lens aperture.

The old-fashioned box cameras were all preset to focus best at approximately twelve feet to infinity, with a shutter speed of 1/50 and an $f/11$ lens. Millions of great snapshots were and still are made with simple cameras.

The trick is to avoid getting so hung up on the technical side of photography that by the time you're ready to point the camera, the scene or event that inspired you to shoot is gone or finished. The modern, self-setting idiot-proof camera has the great advantage of being ready instantly—as long as the batteries are fresh.

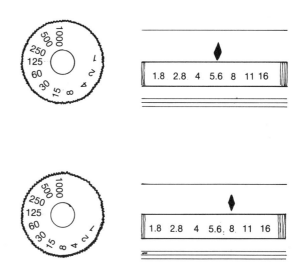

When all else fails, Kodak's estimate sheets can be helpful. *Follow the instructions!*

SUGGESTED EXPOSURES FOR KODAK FILMS

Picture Subject	KODACHROME 64 (Daylight), ASA 64* EKTACHROME 64 (Daylight), ASA 64 KODACOLOR II, ASA 100	EKTACHROME 200 (Daylight), ASA 200 EKTACHROME 160 (Tungsten), ASA 160 normal processing VERICHROME Pan, ASA 125 PLUS-X Pan, ASA 125	EKTACHROME 400 (Daylight), ASA 400– normal processing EKTACHROME 200 (Daylight), ASA 400– EKTACHROME 160 (Tungsten), ASA 320– (Processing for 2 times normal film speed) KODACOLOR 400, ASA 400 TRI-X Pan, ASA 400	EKTACHROME 400 (Daylight), ASA 800– (Processing for 2 times normal film speed)
AT HOME				
Home interiors at night—				
Areas with average light	¼ sec f/2.8	1/15 sec f/2	1/30 sec f/2	1/30 sec f/2.8
Areas with bright light	1/15 sec f/2	1/30 sec f/2	1/30 sec f/2.8	1/30 sec f/4
Candlelighted close-ups	¼ sec f/2	⅛ sec f/2	1/15 sec f/2	1/30 sec f/2
Indoor and outdoor holiday lighting at night, Christmas trees	1 sec f/4	1 sec f/5.6	1/15 sec f/2	1/30 sec f/2
OUTDOORS AT NIGHT				
Brightly lighted downtown street scenes (Wet streets add interesting reflections.)	1/30 sec f/2	1/30 sec f/2.8	1/60 sec f/2.8	1/60 sec f/4
Brightly lighted nightclub or theatre districts—Las Vegas or Times Square	1/30 sec f/2.8	1/30 sec f/4	1/60 sec f/4	1/125 sec f/4
Neon signs and other lighted signs	1/30 sec f/4	1/60 sec f/4	1/125 sec f/4	1/125 sec f/5.6
Store windows	1/30 sec f/2.8	1/30 sec f/4	1/60 sec f/4	1/60 sec f/5.6
Subjects lighted by streetlights	¼ sec f/2	⅛ sec f/2	1/15 sec f/2	1/30 sec f/2
Floodlighted buildings, fountains, monuments	1 sec f/4	½ sec f/4	1/15 sec f/2	1/30 sec f/2
Skyline—distant view of lighted buildings at night	4 sec f/2.8	1 sec f/2	1 sec f/2.8	1 sec f/4
Skyline—10 minutes after sunset	1/30 sec f/4	1/60 sec f/4	1/60 sec f/5.6	1/125 sec f/5.6
INDOORS IN PUBLIC PLACES				
Swimming pool—tungsten light indoors (above water)	1/15 sec f/2	1/30 sec f/2	1/60 sec f/2	1/60 sec f/2.8
Hospital nurseries	1/30 sec f/2	1/30 sec f/2.8	1/60 sec f/2.8	1/60 sec f/4
Church interiors—tungsten light	1 sec f/5.6	1/15 sec f/2	1/30 sec f/2	1/30 sec f/2.8
Stained-glass windows, daytime—photographed from inside	Use 3 stops more exposure than for the outdoor lighting conditions.			
Glassware in windows, daytime—photographed from inside	Use 1 stop more exposure than for the outdoor lighting conditions.			

☐ For color pictures of these scenes, use Tungsten film for the most natural rendition. You can also use Daylight color film, but your pictures will look yellow-red.

☐ For color pictures of these scenes, use Daylight film. You can also use Tungsten film with a No. 85B filter over your camera lens. When you use this filter, give 1 stop more exposure than that recommended for daylight film in the table.

☐ For color pictures of these scenes, you can use either Daylight or Tungsten film. Daylight film will produce colors with a warmer, more yellowish look. Tungsten film produces colors with a colder, more bluish appearance.

* You can take pictures on KODACHROME 25 film (Daylight) by using approximately 1 stop more exposure than recommended for KODACHROME 64 Film (Daylight).

† When the lighting at these events is provided by mercury-vapor lamps, you'll get better results by using Daylight film. However, your pictures will still appear greenish.

Use a tripod or other firm support for shutter speeds slower than 1/30 second.

With KODACOLOR Films you can take pictures of all the scenes listed in the tables and get acceptable color quality.

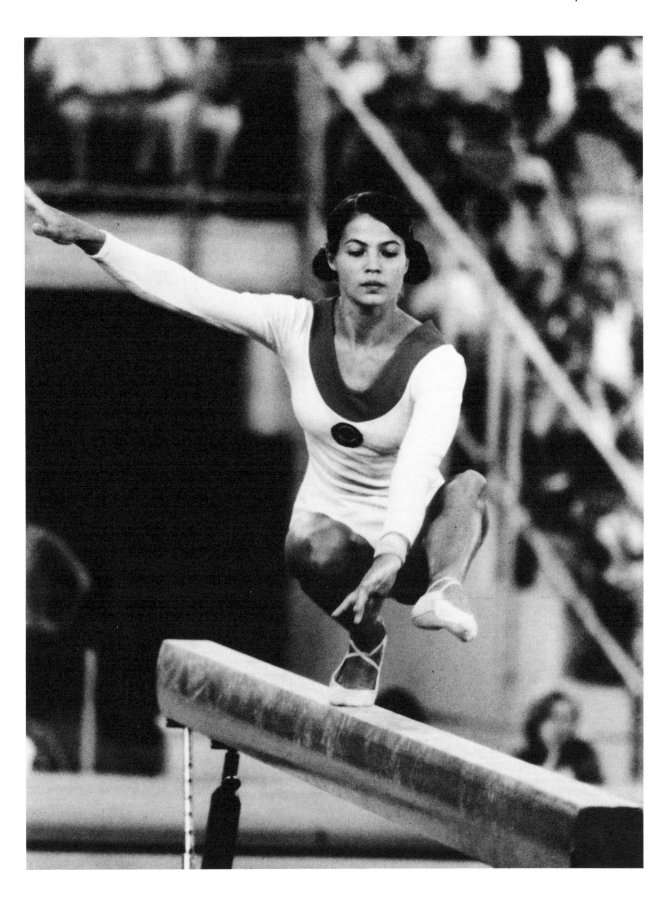

5
Filters

The most practical filter for the would-be sports photographer is the skylight or 1A filter, whose glass is relatively clear and colorless but for a slight pink tone, and whose theoretical function is to cut down on haze in distant backgrounds. It really works to a slight extent, which you can prove for yourself by shooting a scenic view in color or black and white with the filter and then without the filter. It may be difficult to tell which frame is which, but Kodak's sensitometrists and other scientists have published tons of data, and it's a waste of time to argue with good research.

The more important reason that you should use one of these clear, skylight, 1A or haze filters is simpler: the relatively inexpensive filter protects your relatively expensive lens. Sand blows against it, water drops bounce off it, your nylon tie sandpapers its glass, food stains and thumbprints land on this heroic piece of glass—and the constant wipings and polishings wear away the coated surfaces. Thus, you know that you are saving your lens's delicate and expensive coating untold wear and tear.

At this point I should mention that the photo magazines have recently given space to well-intentioned, purist photographers who claim that you lose a small amount of sharpness shooting through a skylight filter. Ultraviolet rays, which are supposed to be knocked out by your UV filter, are no hazard, the argument goes, because the well-coated front surface of your lens performs that function better.

All true. But the amount of sheer quality subtracted from a transparency or black-and-white negative by a clean skylight filter is truly minuscule. The protection is just good insurance, worth the premium to almost every pro I know. I must have a collection of fifty rubbed out, bent-ringed skylight filters, veterans of the sports photography wars that saved injuries to expensive lenses. I also have a drawer full of lenses that have fallen in combat—scratched in the careless process of being unfiltered and hurriedly packed into a camera case in which a metal lens mount of another lens scratched the front surface of an unprotected lens. Fifteen years ago lenses were relatively inexpensive for the professional. Now, how-

ever, the $70 medium telephoto costs four times that. An $8 filter will help preserve your good lens.

Filters for black-and-white photography beyond the UV-haze variety are fairly simple.

Without going into the physics of the light wavelengths and color temperatures involved, suffice it to say that a sports photographer working in black and white can do many assignments before the presence or absence of a filter will be responsible for a lost picture. On the other hand, the creative use of filters may add sufficient interest to a picture to transform it from an ordinary sports picture sold only to the local editor to a sparkling prizewinner.

The everyday filters are the yellow, green, red, and the Polaroid filter.

The yellow filter (available in shades ranging from pale to deep yellow), used with a film like Tri-X or Plus-X, will prevent a cloud-studded blue sky from coming out too white. It will darken the blue sky and make the clouds stand out in white contrast. Like the haze filter, the yellow will penetrate deep haze at infinity and pull in landscape features that may have been hard to see through the finder.

If you are of an experimental nature, you might try an orange filter for deeper sky tone and more separation between those white clouds and their blue background. However, you must vary your exposure quite a bit with orange filters. You lose a half to a full stop with a yellow filter. The orange filter usually sets you back two to four stops.

Every beginning photographer must try the red filter. Those blue skies turn absolutely black. Flesh tones become chalky. The picture looks like it was taken in another world—and it was. To go deeper into this red world, you should try a roll of infrared film and the proper (no. 25) red filter. (Most lenses have a little red dot that tells you where infinity is for infrared films. It is generally around twenty to thirty feet. That is, you'll be looking at a blurred infinite scene, but your camera will be focusing those infrared rays sharply. Infrared is very slow film, and the filter costs you several more stops. An average sunny scene might be exposed at 1/30 f/4.

Note here that any filter placed in front of the lens cuts ultraviolet haze. If you use a yellow filter, remove your regular UV or skylight filter first.

A light green filter will cost you two stops of exposure, but it will also give you terrific flesh tones outdoors, as well as indoors under tungsten lamps. Portraits take on a kind of vacation-tan skin texture because the green, in effect, knocks out the reds and pinks present in many faces.

Neutral density (ND) filters are another breed that is occasionally useful to the sports photographer. Eastman Kodak, Tiffen, and a few other companies make these gray to black filters. All they do is cut down the amount of light passing through your lens to the film. This permits you to use fast film or very slow shutter speeds in sunlit scenes.

The Polaroid filter will cost you one and a half stops, but by twisting it you'll see how it darkens a sky, changes reflections, and gives you better color saturation. It is fine for water and when you want to open up your lens to accommodate fast film. This filter only works on a portion of the sky relative to the sun's position, so look through it until you learn its glories and limitations.

The most useful kit for the sports photographer might contain the following three filters in addition to the Polaroid:

Filter	Multiply Normal Exposure by:	Open Your Lens Stops
ND 0.3 (2X)	2	1
ND 0.6 (4X)	4	2
ND 0.9 (8X)	8	3

There are also in-between filters. Automatic exposure cameras are in their glory computing exposures with ND filters or combinations of

them. Here is a good typical use for an ND filter: You want to shoot a biker zipping along in sunlight. You want the background blurred, so you must shoot at 1/15 second. This might call for an exposure of 1/15 at $f/32$. Your lens can only be stopped down to $f/16$. You whip out that ND 0.6, the four-times filter, and open your lens to $f/16$—that is, two stops down from $f/32$—and there you have it.

Another useful filter is the polarizing filter. By turning this filter you can do marvelous things, such as make reflections disappear from glass, water, or other surfaces. This filter darkens skies in black and white, as well as in color, but it costs you 1½ stops of exposure! For complicated optical reasons, the polarizing effect works better in some sunlight situations than in others.

Meters in cameras behave strangely when reading light coming into the camera through one of these useful filters. As when you are in doubt, it is best to bracket your exposures.

One of the wonderful things about filters for color photography is that if you don't use them on your camera when shooting, and your exposure is good, you (or a good lab) can add the filter later! This is done by making a copy transparency of your transparency through the filter you think you'd like. The copy is generally good enough for most uses. Printers prefer to make their own corrections when printing, but only the very best printers (a small minority of those in the field) consistently make good corrections.

Imagine that you shot that racquetball or squash match under arc lamp lights and your pictures show green people and green walls. At a good lab they will use some deep magenta filter gels inside their slide copier, and pretty soon they can add and subtract correction filtrations so that flesh tones appear as if by magic and those green walls turn a more respectable white.

All of the photographer's filter problems would be resolved if someone were to invent a film that automatically photographed what the human eye thinks it is seeing. Kodak's Kodacolor 400 comes closest to this, but it's better for the novice sports photographer to learn something about the color temperatures of various kinds of light and get a few filters.

Color temperature is measured in degrees Kelvin. Most of Kodak's film for daylight use is balanced at 6000 degrees K for Washington, D.C., noon sunlight. Most of the rest of U.S. latitudes average 5500 degrees K or so. Electronic flash units throw out light that is 6000 K. However, the game becomes more complicated when you go indoors. At right are some temperatures of various light sources:

Kodak and several other companies make filters capable of bringing the color temperature of these various light sources to the basic mid-range or optimum range of daylight film or of tungsten film.

In general, if you have a mixed light source—some daylight and some tungsten—the more pleasing picture is generally possible on daylight film. The flesh tones go warm toward the yellow-orange side. This is more visually pleasing than the blue flesh tones that tungsten film reads when used in daylight.

The best all-around film in the world, the film favored by the majority of professionals as their prime carry-around film, is Kodachrome 64. This daylight film can be used with 3400 K floodlights by adding an 80B filter (blue in color) to the lens and cutting exposure 1⅔ stops, that is, opening up from $f/8$ to approximately $f/4.5$.

Kodachrome 40 tungsten, another popular state-of-the-art film, designed for 3400 K floodlights, becomes a perfect outdoor Kodachrome 25 daylight film through the addition of a Type A filter called the 85. It is orange in color.

The sports photographer carrying lots of 200 or 400 daylight Ektachrome should also carry an 80B filter called a Type B filter. This cuts the exposure 1⅔ stops, but when the TV guys turn on their lights after the game to interview the heroine or hero, you put on your bluish 80B filter and avoid getting faces that are too gold-orange, as they would be if unfiltered.

By far the sports photographer's most puzzling lighting problems will come from fluorescent and arc lamps.

Eastman Kodak and Time Incorporated's labs have found success in using the following filters with the following light sources. Your meter will be of great value in using these

Source	Color Temperature (K)
Sunset	2000
Campfire	1800
Household tungsten lamps:	
40-watt	2600
75-watt	2800
100-watt	2900
200-watt	3000
3200 K Photo lamps	3200
3200 K Color film	3200
3400 K Photo lamps	3400
3400 K Color film	3400
Clear aluminum-filled flashbulbs	3800
Clear zirconium-filled flashbulbs	4200
Blue photoflood lamps	4800
Direct sunlight	5000
Theatrical arc lamps	5000
Standard photographic daylight	5500
Daylight color film	5500
Blue flashbulbs	5500
Electronic flash	6000
Sky—heavy overcast	6500
Sky—light overcast	7500
Sky—hazy blue	9000
Sky—clear	12,000 to 20,000

filters, especially when sandwiching several of them. Filter factors will run from losing two-thirds of a stop for the 30 magenta to losing two stops for some of the deeper-colored sandwiches.

Many manufacturers make an FLB and FLD filter for daylight film shot under average fluorescent lights. These cost you a stop. The 30M, costing two-thirds of a stop, is a good all-around correction filter for daylight film shot under fluorescent light.

Some of Kodak's recommendations follow on page 44.

I have reprinted some recommendations of Time Incorporated and Kodak for filtering arc lamps of various types. I would also like to share my own discovery, now commonly used in photographing racquetball tournaments. For situations in which you have a certain amount of control—as in a racquetball match—and you are able to set up several 1000-watt tungsten floods, you can shoot daylight color film without any filter at all! The orange tone you'd expect from the floodlights with daylight film melds beautifully with the arc lamps, giving you good flesh tones. I have used floods like this in shooting annual report pictures in factories, and the system works surprisingly well.

To give you some idea of the plethora of filters available to you, I am reprinting the Tiffen Company's offering of filters and its useful explanations of how to use them (see pages 42 and 43).

There is some variation in the numbers assigned to filters sold by other companies, but the main series—the 80s, 81s, and 85s—are usually called by those numbers universally.

To sum up, very few black-and-white pictures are lost because of an absence of filters. Many black-and-white pictures are lost due to underexposure—not allowing enough exposure for the light to get through some of those three-times green filters.

I would recommend that you step into the world of filters with your lens-protection haze-skylight filter and move from there to a polarizing filter. Idly turning the filter around,

TĬFFEN FILTERS

for color film

FILTER NO.	FILM TYPE	LIGHTING	f STOP INCREASE	SUGGESTED USES
CLEAR	All films	All	—	Optical glass lens protection with no color shift
SKY 1A	Daylight	Daylight	—	Use at all times, outdoors, to reduce blue and add warmth to scene. Also in open shade
HAZE 1	Daylight	Daylight	—	Reduce excess blue caused by haze and ultra-violet rays. Ideal for mountain, aerial and marine scenes
HAZE 2A	Daylight	Daylight	—	Greater ultra-violet correction than Haze #1 filter and adds some warmth to the visible colors
UV15	Agfachrome Anscochrome Daylight	Daylight	—	Haze filter, also for Anscochrome 3200°K film with photofloods
UV16	Daylight	Electronic flash Daylight	—	Reduces excessive blue in electronic flash, also may be used for haze correction
UV17	Daylight	Daylight	—	Greater haze correction, reduces blue in shade
80A	Daylight	3200°K floods	2	Converts daylight film for use with 3200°K lamps
80B	Daylight	3400°K floods	1⅔	Converts daylight film for use with 3400°K flood
80C	Daylight	Clear Flash	1	For use with clear flash and daylight color films.
80D	Daylight	AG-1 clear flashbulbs	1	For use with clear flash and daylight color films. Warmer results than 80C
81	Daylight	M2 flash	⅓	Yellowish, warming filter
81A	Type B	Electronic flash 3400°K floods	⅓	Balances daylight films to electronic flash. Corrects Type B films for use with 3400°K lamps. Prevents excessive blue
81B	Type B	Electronic flash 3400°K floods	⅓	Warmer results than 81A
81C	Type A, B	Clear flash	⅓	Permits the use of clear flash lamps.
81D	Type A Type B	Clear flash	⅔	Permits the use of clear flash except SM or SF. Will render warmer results than #81C filter
82	Daylight	Daylight	⅓	For any 100° increase in Kelvin temperature for color renderings.
82A	Type A Daylight Negative	3200°K floods Early AM, late PM 3400°K floods	⅓	With Daylight and Daylight Negative films use in early AM or late PM to reduce the excessive red of the light. When using Type A (3400°K) films under 3200°K lamps.
82B	Type A	3200°K floods	⅔	For cooler results
82C	Type B	3200°K floods	⅔	For cooler results or when using 3200°K lamps
85	Type A	Daylight	⅔	Converts Type A film to Daylight.
85B	Type A, B	Daylight	⅔	Converts Type B film to daylight.
85C	Kodacolor, Ektacolor, Agfacolor CN 14, 17	Daylight	⅓	Helps prevent overexposure of blue record layer.
CC30R	Daylight	Daylight	⅔	For under water photography, to correct color. Also, to compensate for distortion of color when shooting through transparent plastic windows similar to vistadomes provided by railroads for camera fans
FLB	Type B	Fluorescent	1	Eliminates the deep blue-green cast ordinarily resultant from shooting color films with fluorescent lights.
FLD	Daylight	Fluorescent	1	Eliminates the deep blue-green cast ordinarily resultant from shooting color films with fluorescent lights.
Neutral Density	All Film Types Color or Black and White	All light sources		For uniform reduction of light with high-speed films for still and movie cameras. No change of color value.
Polarizer	All Film Types Color or Black and White	All light sources	2	Eliminates surface reflections, unwanted glare or hot spots from any light source. The only filter that will darken a blue sky and increase color saturation.

820B and 840B FILTERS For POLACOLOR® Film 820B with 3200°-3400°K (300 W MP3)
840B with 2800°-2900°K (150 W and 75 W MP3)

for black and white film

FILTER NO.	COLOR OR NAME	SUGGESTED USES	f STOP INCREASE ORTHO		f STOP INCREASE PAN	
			Day-light	Tung-sten	Day-light	Tung-sten
3	(Aero 1)	Aerial photography, Haze penetration	1	⅔	⅔	—
6	Yellow 1	For all black and white films, absorbs excess blue, outdoors, thereby darkening sky slightly, emphasizing the clouds.	1	⅔	⅔	⅔
8	Yellow 2	For all black and white films, most accurate tonal correction outdoors with panchromatic films. Produces greater contrast in clouds against blue skies, and foliage. Can be used for special effects with color film.	1⅓	1	1	⅔
9	Yellow 3	Deep Yellow for stronger cloud contrast	1⅓	1	1	⅔
11	Green 1	For all pan films. Ideal outdoor filter where more pleasing flesh tones are desired in portraits against the sky than can be obtained with yellow filter. Also renders beautiful black and white photos of landscapes, flowers, blossoms and natural sky appearance	—	—	2	1⅔
12	Yellow •	"Minus blue" cuts haze in aerial work, excess blue of full moon in astrophotography. Recommended as basic filter for use with Kodak Aero Ektachrome Infrared.	1⅔	1⅓	1	⅔
13	Green 2	For male portraits in tungsten light, renders flesh tones deep, swarthy. Lightens foliage, with pan film only.	—	—	2⅓	2
15	Deep Yellow	For all black and white films. Renders dramatic dark skies, marine scenes; aerial photography. Contrast in copying	2⅓	1⅔	1⅔	1
16	Orange	Deeper than #15. With pan film only	—	—	1⅔	1⅔
21	Orange	Absorbs blues and blue-greens. Renders blue tones darker such as marine scenes. With pan film only	—	—	2⅓	2
23A	Light Red	Contrast effects, darkens sky and water, architectural photography. Not recommended for flesh tones. With pan film only	—	—	2⅔	1⅔
25A	Red 1	Use with pan films to create dramatic sky effects, simulated "moonlight" scenes in mid-day (by slight under-exposure). Excellent copying filter for blueprints. Use with infra-red film for extreme contrast in sky, turns foliage white, cuts through fog, haze and mist. Used in scientific photography	—	—	3	2⅔
29	Dark Red	For strong contrasts; copying blueprints	—	—	4⅓	2
47	Dark Blue	Accentuates haze and fog. Used for dye transfer and contrast effects	—	—	2⅓	3
47B	Dark Blue	Lightens same color for detail	2⅔	3	3	4
56	Light Green	Darkens sky, good flesh tones. With pan film only	—	—	2⅔	2⅔
58	Dark Green	Contrast effects in Microscopy, produces very light foliage	3	2⅓	3	3
61	Dark Green	Extreme lightening of foliage	—	—	3⅓	3⅓
64	Green	Absorbs red				
70	Dark Red	Commercial darkroom work only				
72B	Dark Orange	Commercial darkroom work only				
74	Dark Green	Mercury lamp, commercial darkroom work				
23A + 56		Creates night effects in daylight, with pan film only				
87		For infra-red film only, no visual transmission				
87C		For infra-red film only, no visual transmission				
89B		For infra-red film only.				
113		For infra-red film only, no visual transmission				
Neutral Density	All Film Types Color or Black and White	For uniform reduction of light with high-speed films for still and movie cameras. No change of color value	Available .1, .2, .3, .4, .5, .6, .7, .8, .9, 1.00 Neutral Densities. Available in all series sizes.			
Polarizer	All Film Types Color or Black and White	Eliminates surface reflections, unwanted glare or hot spots from any light source. The only filter that will darken a blue sky and increase color saturation.	2	2	2	2

f STOP INCREASE BASED ON USE AND PROCESSING

Exposure depends on hour of the day and amount of light reflected from object photographed after the glare has been penetrated. If picture is taken through glass or water, additional exposure will be required.

NOTE: All exposure increases shown are approximate, and should be varied with differences in light and subject.

FILTERS FOR USE WITH FLUORESCENT LIGHTING						
Kodak Film Type	*Type of Fluorescent Lamp*					
	Daylight	*White*	*Warm White*	*Warm White Deluxe*	*Cool White*	*Cool White Deluxe*
Daylight and Type S Professional	40M + 30Y	20C + 30M	40C + 40M	60C + 30M	30M	30C + 20M
Tungsten, Type B (3200 K) and Type L Professional	85B + 30M + 10Y	40M + 40Y	30M + 20Y	10Y	50M + 60Y	10M + 30Y
Type A (3400 K)	85 + 30M + 10Y	40M + 30Y	30M + 10Y	NO FILTER	50M + 50Y	10M + 20Y

darkening skies over slopes, cutting out reflections on the water, making sails stark white against dark gray or blue skies, is lots of fun. So is figuring out the average exposure, which may vary from quadrant to quadrant in the sky. So experiment!

The 85 filter, orange in color, is useful for converting your tungsten film to daylight. The blue 80A and 80Bs do a fine job of converting your daylight film to tungsten, with a two-thirds- to two-stop loss. (Remember, you can lop some of that loss from the shutter as well as the aperture. That is, if unfiltered exposure is 1/125 at f/8, two stops from that reduces your exposure to 1/125 at f/4; but it's also a two-stop drop if you shoot at 1/60 at f/5.6.)

There are some wild filter sets made by Cokin and others—filters that darken the top of your picture, make it pink or green in varying degrees, and can otherwise drive you into deep experimental photography, if you have the time and the inclination.

I've seen fine pictures taken with these wild filters, but they always remind me of an early TV invention. It was a three-colored piece of gelatin that fit over your black-and-white screen and colored the sky blue, the center reddish, and the foreground earth grass-green. This was OK until they ran out of oat operas. Experiment! Bracket exposures! Astonish yourself!

6
Care of Equipment

Sports photography is, unfortunately, rough on equipment. Modern photographic equipment is amazingly tough and forgiving, but the sports arena holds more hazards for camera gear than a golf course has sand traps. Outside the sports arena—along the water's edge, on it, under it—the hazards are fairly obvious. Sand and water, of course, are the greatest enemies of the camera and lens. Sand works its way into everything if you set equipment down on it or drop gear onto it. The tiny grains impede the smooth operation of the camera's gears. Rubbing that sand off a bit too roughly can scratch those valuable lenses. And water! Salt water is insidious. Repair people groan when a camera retrieved from the deep comes in to be "dried out." If you (shudder) drop your gear into salt water and retrieve it, and you can't get to your repair person in time, some repairers recommend (gulp!) that you put·the stuff under fresh tap water, just to wash the salt out.

To minimize the odds against dropping cameras, make sure the strap hooks are secure and, if there's any doubt, liberally cover the point of attachment with thin, girdling strips of electrical or Mystik-type tape.

Carry an air bulb camera brush, lens cleaning tissue, and some Kodak lens cleaner. Brush gently, and use the tissue lightly.

In the excitement of sporting events, the crowd is your enemy. People are happy, tense, drunk, argumentative, hostile at sporting events. They rush around with their eyes glazed, especially before the event starts. It is during this pre-event period that you must be especially alert to having your camera and tripod trampled by some oaf looking north while running south en route to the john or the hot dog stand.

If you have some choice as to position, take one that affords you some cover in the true military sense. Use a post alongside you, a blank wall, the side of a box, or an assistant leaning on the tripod.

At the last moment in some events, the real pros come in. Hockey rinks, baseball clubs, and a few other managements assign, formally

or informally, a few spots to the regular, local newspaper and wire service photographers. Having arrived an hour early and set up in one of these generally unmarked positions, it comes as a surprise when you are asked, with varying degrees of politeness, to move. But fellow sports photographers, while competitive as can be, will not hurt your equipment. In fact, there is an unwritten canon among sports photographers that says, "I'll keep an eye on your stuff if you change positions if you'll do the same for me." Even as a semipro, your gear will be fairly safe.

I do not know of any incidents of large-scale camera or lens theft at a sporting event with one exception: the Montreal Olympics in 1976. One *Life* photographer had four lenses stolen during the second day. Nikon's then-new nicad battery packs that activated the motor drives were stolen by the score from American photographers, who had brought most of them.

Under less exotic conditions, it is often prudent to pick a friendly couple from the crowd behind the first row and ask them to keep an eye on your camera gear as you wander up and down the sidelines. If you use an assistant, be sure to introduce him or her to these nice people, so they don't call the police when you send your assistant for more film or for the wide-angle lens you never thought you'd need.

The single-lens reflex is basically a well-designed, strong, forgiving device. However, when you hang a three- or four-pound telephoto lens from it and race up and down a sideline or along a golf course, that front mount gradually pulls out a little and your pictures will not be as razor sharp as you thought they would be when you focused and snapped. Normally, the mount and the mirror box prism arrangement that permit you to view your subject right side up are set precisely and are in an absolutely direct relationship to the distance your image travels from the front of your lens to the film. The partial detour your picture takes, thanks to the mirror and prisms, is merely for your viewing convenience. The crucial event occurs when the mirror lifts up and the shutter implants what you saw on the film. If that front mount is pulled even a hair out of line, or out of its

original specification, you'll have a problem of soft focus, especially with wide-aperture lenses that are not stopped down. To test any problems you may suspect in this respect, set your camera on a tripod and focus on a wall of books or a newspaper tacked to the wall. Then mark an X in the newspaper and focus on the X at about 45 degrees. The error, if any, will show up best at the shorter distances. Eight to ten feet is a good test distance.

If either of these test pictures is out of focus, it's probably due to lens mount trouble brought on by a heavy telephoto, or to someone's shoulder lurching against your lens as you shoot. It doesn't take much of a lurch to bend that camera mount, so guard your shooting position with your elbows and a firm stance.

NORMAL PREVENTIVE CARE

There was a *Life* photographer who was so fastidious about caring for his lenses and cameras that he had a kind of half-hour ritual that he performed both before and after shooting a picture. The ritual consisted of carefully opening his huge, fitted, compartmented case and extracting the lenses, cameras, filters, cable releases, etc., that he would need. But each of these valuable items was in its own specially made, fitted, and labeled case.

At least half a dozen times, when working as a young *Life* reporter, I saw this photographer miss great pictures because he was either packing up or unpacking his equipment.

On the other hand, Francis Reeves Miller used to pile his cameras into a leather case, metal on metal, protecting the glass with UV filters (still a great idea) and sandwiching boxed rolls of film between the more delicate items. He also used the empty film cases to store little sips of Jack Daniels whiskey as well as to cushion his gear. Of course, lenses and cameras were approximately eight times cheaper in those days, and replacing a lens wasn't an earth-shattering financial move.

Actually, scratched lenses and wounded lens mounts are almost as forgiving as modern color film. A lens scratch looks terrible, of course, and reflects badly on its owner, but the picture produced by it will be indistinguish-

able from that resulting from an unscratched lens. I'm talking about one or several scratches on the lens's surface—the kind that often mars the beautiful yellow, tan, or bluish coating.

There's a complicated optical reason for this. In simplified terms, the lens loses only a minuscule amount of overall light, the percentage of the lens area occupied by the scratch. If the scratch covers 1/10,000 of the lens's surface, your lens will, in effect, act as if stopped down 1/10,000 of a stop—or nothing discernible by anyone without an optical computer.

Burred and scratched lens mounts come from clinking these items against others on a second or third camera toted by the busy sports photographer.

These burrs reduce the trade-in value of the lens to a great extent, but most sports photographers keep their lenses for years, or until the manufacturers advance the state of the art—an upheaval that is going on this very moment with the introduction of the rare glasses and single-element focusing into lens design.

Of course, the trick is to carry your equipment in easily opened leather, plastic, or the new blow-up lens bags (made by SIMA). By the way, SIMA also makes the controversial lead-lined film protection bag. The consensus among traveling pros is that you are fairly safe (but not entirely) getting your film X-rayed at most U.S. airports. Overseas, the bags are a must, because X-ray techniques are awful in many places.

It is sometimes possible to talk your film around the X-ray machine in the United States, but this is harder to do overseas.

All of your lenses should have protective UV or skylight filters on them. These cut into the blue distant haze, cut down on some of the ultraviolet light, and, most of all, keep your lenses from bearing the accidental scratches and buffeting they invariably take as they hang from your neck.

If you are serious about sports photography, you will be using motor winders or motor drives on your single-lens reflex cameras. The single largest cause of malfunction in these useful and fairly dependable gadgets is poor battery contact. The metal contacts must be cleaned. Use a pencil eraser or, if they are greenish and corroded, clean them with cotton swabs dipped in water and baking soda.

Some motor winders have such a critically small contact area with batteries that certain brands of alkaline batteries can't be used. One brand, for example, sells a battery that has a dimple on the bottom. This slight depression is OK when the batteries are mounted in tandem, but when the dimple has to touch a contact point, your winder often goes dead.

It's a good idea to mount an inexpensive battery tester in your darkroom or basement. It will save you much anguish in trying to decide whether to keep or throw away a battery that has been used for a few jobs. It will also help you decide whether you should go into the nicad and recharger business and save battery money. In general, the nicad batteries and rechargers made by the camera companies for their motor drives are just great, if used according to the directions. Like the human brain, nicads work better and better the more you use them.

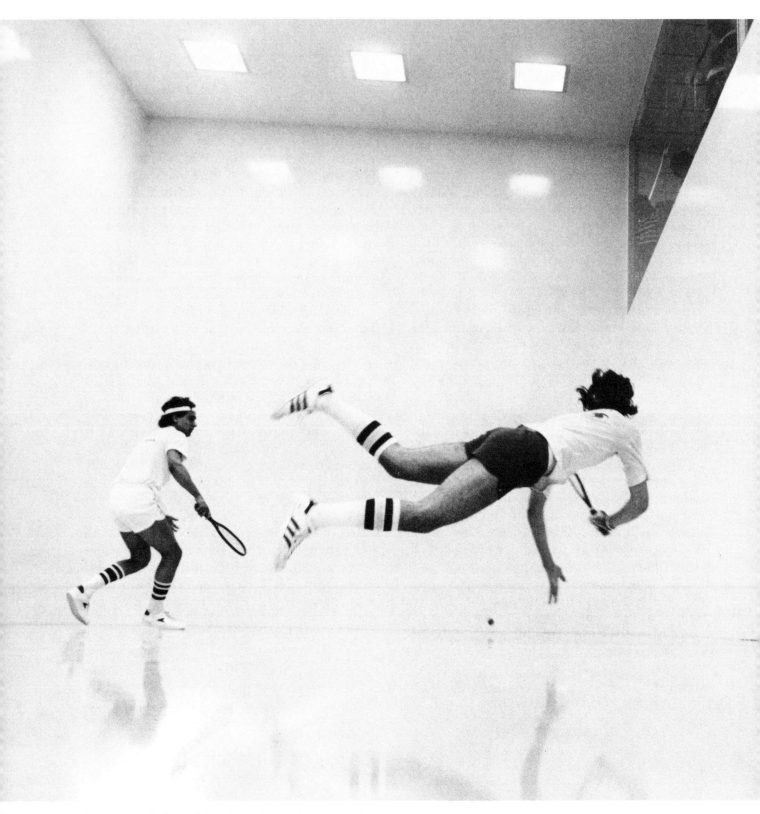

The racquetball pro flying through the air was caught at an exposure of 1/250 at f/2.8. The glass back wall of many racquetball courts provides a novel window on a fast sport for the photographer.

7

Technical Section

SHOOTING UNDER TUNGSTEN LIGHTS

The serious sports photographer should check on the type of lighting in the stadium or arena before the sporting event takes place. The best way to do this is to call the stadium's public relations person, who will either have the information you need or refer you to the house electrician. Better yet, he or she can refer you to the local newspaper's chief photographer, who may or may not be cooperative.

The easiest lights to shoot under are plain screw-in tungsten bulbs. Arenas that are used for TV coverage, as in many basketball gyms, often have banks of these helpful tungsten lights along one or both balconies. That local photographer, if you get him or her talking, can give you such vital tips as, "I always use Kodak Ektachrome 160 professional film, push it a stop, and get beautiful color at 1/250 second at $f/2.8$. You will, of course, want to check this out with your light meter when you get to the arena, but you'll know that you will be OK bringing lots of tungsten film with you.

For most magazines that print sports pictures, and for all newspapers, you can push this wonderful 160 film two stops—from ASA 160 to 320 to 640—without getting too much unacceptable grain. The advantage, of course, is in thus being able to shoot at 1/500 second, or to be able to use a longer, slower lens.

It is common to push ASA 400 black-and-white film two stops to ASA 1600 safely. You pick up a little grain and contrast, but you also get pictures you might not have achieved otherwise.

SHOOTING UNDER FLUORESCENT LIGHTS

Shooting black-and-white film under fluorescent-tube lighting is merely a matter of taking intelligent meter readings and usually pushing the film one or two stops to give you an average exposure of 1/250 at $f/2.8$. If the event occurs under fluorescent light and some daylight seeps into the scene, so much the better. It may permit you to stop down to $f/4$.

If you are determined to shoot color under these conditions, there are several ways to go.

The first is to use an FLD filter (fluorescent filter for daylight film). This is magenta in color and worth the price of removing the

fluorescent greens and yellows in one stop. You can also use an FLD filter with tungsten film. This will also cost you one stop.

The easiest method is to make believe you're shooting black-and-white film! Your slides or photo prints from negative color film will be a kind of sickly yellow-green if you used daylight film. But if you were hoping for one or two good shots of an event, your lab can take these greenies, add various shades of magenta to them, and provide you with a more or less perfectly balanced duplicate slide or print without the offending color. This involves an additional duplicate slide expense, but it saves you the trouble of buying various kinds of filters.

The serious photographer who likes to get things right in the camera must take the following steps.

1. Determine by observation or from a friendly janitor, electrician, or PR person the kind of fluorescent lamps being used.

2. If the event you are shooting involves relatively slow action—such as the less frantic moments in a wrestling match, or other sports action requiring 1/125 second or slower shutter speeds—you can easily follow the chart printed above, courtesy of the Time Incorporated photo department. (A Type B filter and daylight filter made by a mysterious Indian named Singh and distributed by Tekno, Inc., in New York, Los Angeles, and Chicago—when Singh ships a fresh supply—are a kind of across-the-board alternative. The Type B Singh with Ektachrome B costs you a stop, but the results are surprisingly good. The Type A Singh is almost as good.)

3. The E-6 Kodak Ektachromes are absolutely marvelous and can be pushed one stop by any good lab. The difference in grain doesn't begin to show up until you've pushed

E-6 film two stops, and for most uses, the two-stop push is acceptable.

The one-stop push permits you to shoot the tungsten 160 film at 320. Subtracting a stop for your Singh filter (Type B)—or an average of a stop for warm white, warm white deluxe, or cool white deluxe lights—permits you to shoot average slow action, such as grappling, swim turns, a slow gymnastic turn, at 1/125 at $f/2.8$. If you're concerned about reproductive quality in a slick paper magazine, and you have a fast telephoto, you can easily shoot at 1/250 at $f/2.8$.

Pushing an extra stop or stop and a half gives you fine slides for home use and good slides for newsprint reproduction.

4. If your main concern is to get some prints for your album or for the team, you will find the Kodacolor 400 negative film amazingly forgiving. It sometimes ignores all the bad lighting and, without a filter, it provides perfectly usable or, at worst, easily correctable, prints.

For more information on fluorescent-light filtering, see chapter on films.

SHOOTING UNDER HIGH VOLTAGE DISCHARGE LIGHTS

The third kind of arena light and the most common is the high voltage discharge lamp known as mercury vapor. These lamps, often used in factories, are economical and long-lasting. However, they raise grievous havoc with color films unless you are prepared to correct your slides at the photo lab after you shoot them. The alternative would be to use the following table which tells you what kind of filter and combination to use for the four major kinds of mercury vapor type lamps.

High Voltage Discharge Lamps

	Lucalux	Multivapor	Deluxe White Mercury	Clear Mercury
KODAK EKTACHROME 200 Prof. Film, 5036	110C +70M	30M +10Y	45M +10Y	70M +65Y
KODAK EKTACHROME 400 Film, 5074	100C +90M	45M +25Y	65M +25Y	25M +40Y
KODACHROME 64 Film, 5032	100C +65M	30M +20Y	50M +35Y	65M +70Y
KODACHROME 25 Film, 5073	130C +65M	20M +10Y	35M +20Y	80M +95Y
KODAK EKTACHROME 64 Prof. Film, 5017	100C +65M	30M +25Y	55M +30Y	70M +65Y
KODAK EKTACHROME 160 Prof. Film (Tungsten), 5037	25C +50M	60M +85Y	70M +75Y	90M +130Y
KODAK EKTACHROME 50 Prof. Film (Tungsten), 5018	20C +45M	60M +90Y	80M +85Y	90M +130Y

Rules of thumb for shooting black and white under arc lamps: 1/250 at f/2.8 with film at ASA 800 when you have fine reflective surfaces like the walls of a squash or racquetball court; 1/250 at f/2 for larger gyms; 1/250 at f/2.8 with film at ASA 1600 for arc-lit basketball or tennis courts. Remember to use your meter!

8
Composition

When I began taking pictures, the photo magazines were full of articles on composition. Photo teachers at the lectures I attended would project slides and say things like, "This line goes off the picture . . . and this line . . . see, this curve (wooden or battery-light pointer tracing it) keeps your eye, and also your interest, right inside the frame. This is what you should try to do."

When I worked at *Life* as a young reporter, toting bags at one time or another for 90 percent of *Life's* photographers, I was surprised to learn that composition was not a big deal to these masters of photography.

John Dominis, now the picture editor of *Sports Illustrated,* told me, "I just frame whatever I want in the viewfinder and cut the rest out."

Francis Reeves Miller said, "In sports photography good composition is anything that gets you a clear sharp view of your subject in action. And try not to cut off an arm or a leg, or Ed Thompson'll get sore." (Ed Thompson was *Life's* most demanding editor.)

The obstacles to filling the photographic frame comfortably are generally extraneous background, foreground, and, indeed, parts of the very subject you are shooting somehow interfering with a clear view of what it is you are trying to show. It's amazing how many fence posts, telephone poles, building corners, spectators looking away from your action, spectators looking right at the camera while the play of the century is unfolding before your lens, and other distractions show up in sports pictures.

Since photography is indeed an art of crowding events into a visual as well as a time frame, the rule of thumb is to shoot the picture first from the best possible spot at which you can sit, stand, or lean. Thus you should be able to cut out, in advance, such eyesores as telephone poles, light stands in the stadium, and the corner of the new student union building. (That stark white will not only be

In the pictures at right, the action is centered, the backgrounds are not confusing. The action is generally closeup. The boxer soaking his aching fists after the match, and the triumphant managerial smirk show up better in the closely cropped frame.

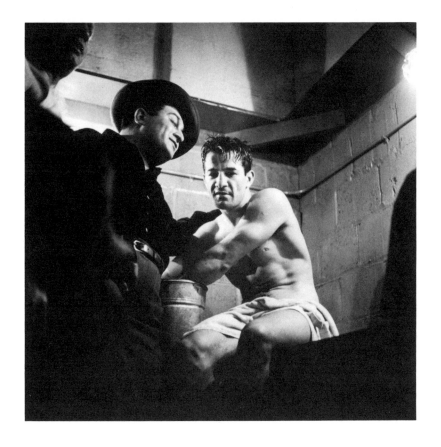

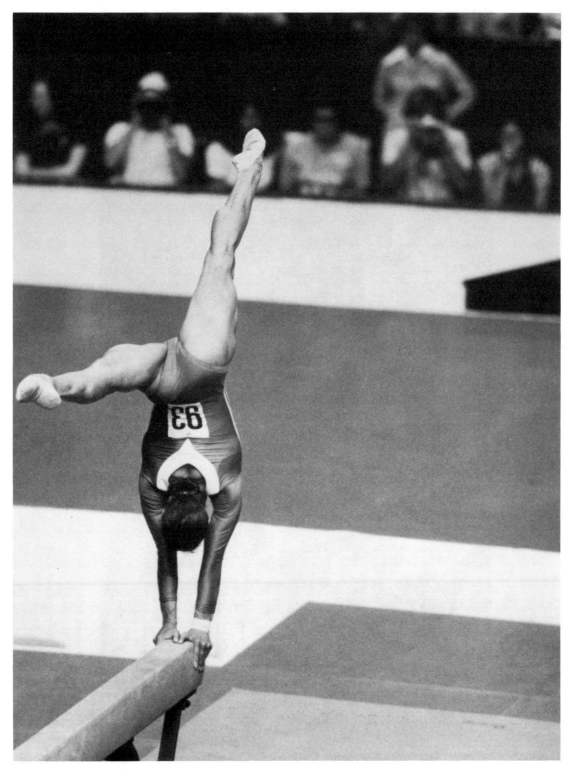

For practical purposes, composition in sports pictures is mostly preordained by the photographer's position, the subject's mobility, the background, and the other obvious variables.

Sports pictures should feel comfortable in their framing. The odd arm or leg flying out of the picture is usually disturbing.

From the same Olympic seat composition can be varied crucially to fit the frame comfortably.

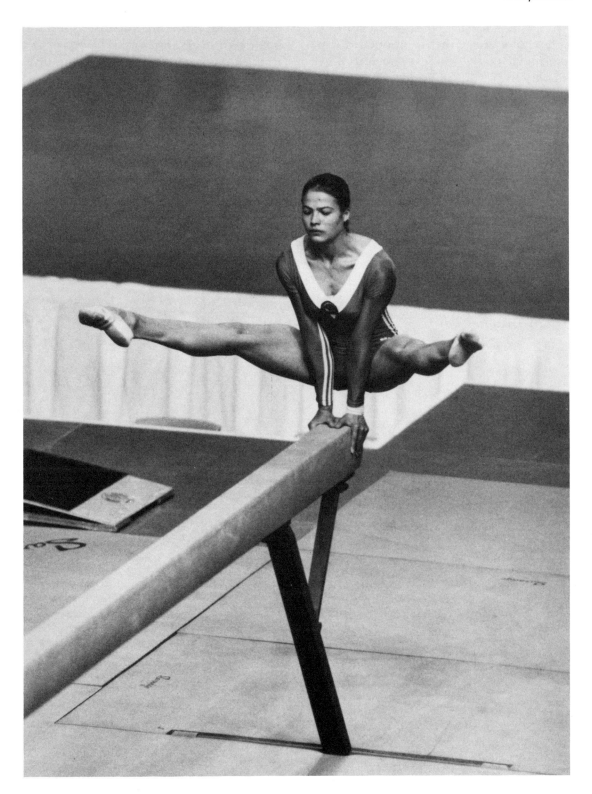

tough to print in black and white, but in color, a flare of white, either in or out of focus, will take much of the interest and initial eye contact away from your main foreground subject, especially if it is in subdued light or subtle color.)

Most magazine sports photographers compose instantly and instinctively, letting the picture arrange itself in the frame. Sharpness and good exposure are often the overriding substitutes for classic composition. By classic I mean those reproductions of a simple scene—boat, swimmers, dock, sky. A series of curves, triangles, and circles are drawn on the picture, with arrows leading the way the eye sees.

A series of eye–camera tests done by Dr. Michael Gerson of New Jersey proved to no one's great surprise that the eye, when confronted with a stimulating sight, responds by focusing on precisely the most interesting part of what it sees. What's more, the iris actually opens somewhat to let more of the scene in. In

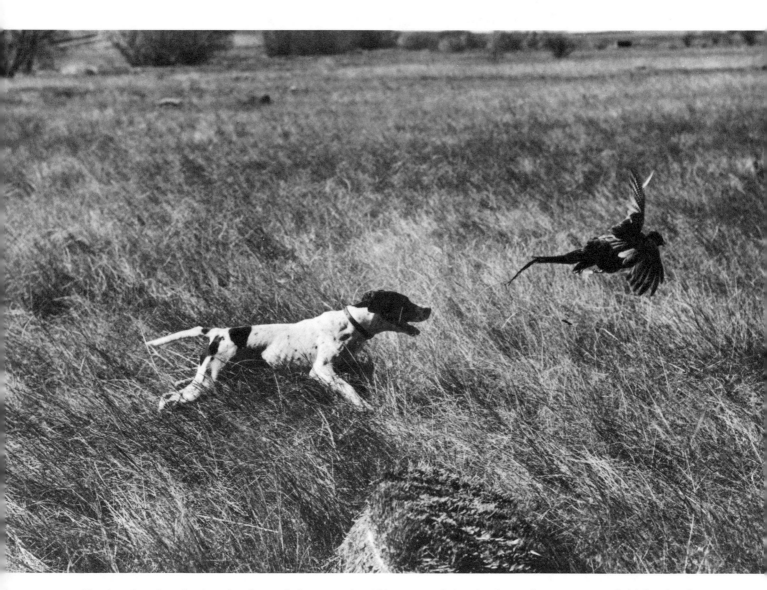

The hunting dog chasing the doomed pheasant should be cropped closely. Cover the extraneous field, leaving just dog and bird. The terrible urgency of a life running out comes through because of the tighter composition.

reverse, the eye shuts a bit to black out an unpleasant or unwelcome sight.

"My studies at Illinois Institute of Technology indicated that the child who was shown a series of undifferentiated pictures betrayed little or no interest. When these pictures were varied in terms of action or background, the child would become alert," said Dr. Gerson. "The idea of what's pleasing in terms of content and composition has to be learned. In TV viewing, especially of sports pictures, children—and adults—respond to the action on the screen. A still screen with a still picture on it for any length of time loses the viewer."

Unless we shoot movies, we can't make our pictures move. But by filling the frame, uncluttering backgrounds and foregrounds if possible, and keeping our action clearly in focus and in view, we can keep our viewers from going to sleep.

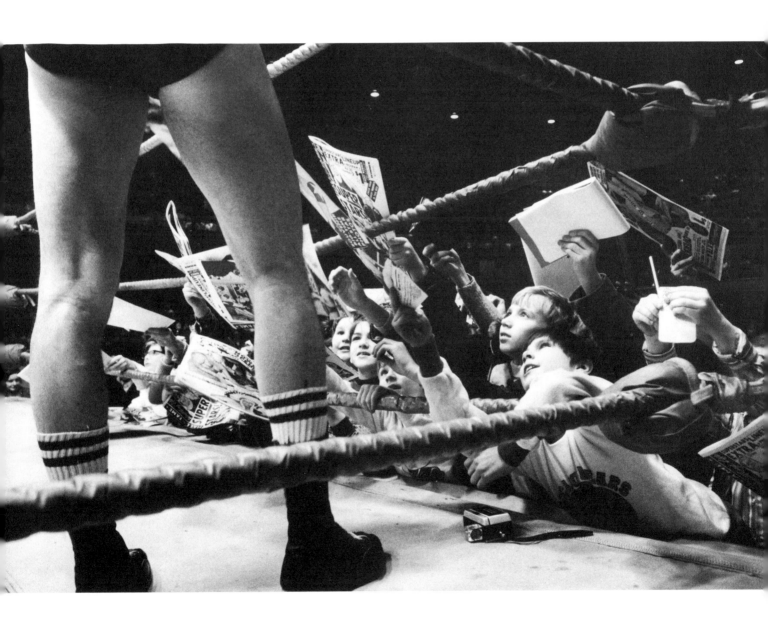

COVERS

When you have advanced to shooting sports covers—your best bet on learning what composition is all about—ask your assigning editor what he or she hopes to get on that cover. Other questions and comments:

1. If the light is good I'm going to use Kodachrome. Do we have a couple of days to allow for processing time?

2. If the light is bad, shall I use Ektachrome 200 pushed a stop? (Ektachrome 200 pushed a stop is practically indistinguishable from Ektachrome 400 unpushed!) Is 35mm Ektachrome's slight grain of good enough quality for your cover?

3. You want a portrait. Should I use 2¼ film?

4. I know you use verticals for covers, but sometimes you use a few shots on the cover. Do you want a horizontal?

5. Do you want a posed or an action shot?

6. How about posed action? (Examples: pitcher warming up on sidelines before the game; quarterback throwing practice on sidelines; ball coming at camera; enough sky for a cover logo?)

Some magazines like to run copy down the left side of the cover. This area should be kept low key and in the shadows if this is a consideration.

Having shot some 1,500 covers, with 17 for *Sports Illustrated,* I still find each cover assignment different and exciting.

For example, the *Discovery* magazine (Allstate Insurance) covers shown involved finding a green forest glade during a Chicago winter. The hiking picture, in summer, involved *buying* some preserved autumn leaves and strewing them in a forest preserve!

9

Tips on Shooting the Most Popular Sports

Children are the best subjects with which the sports photographer can practice.

Use your single-lens reflex and, at first, your normal lens to track one or more youngsters through a backyard or front lawn romp. Let them race around you. Whirl with them, trying to keep your camera in focus and your exposure changing with the changes in your angle. The much maligned but increasingly popular automatic setting or completely automatic camera is just what you need here.

You should cut your teeth on Kodachrome 64, because it is the best all-around color film in the world. You can project it and make prints up to wall size from it. In addition, magazines love Kodachrome, for it engraves so well.

If you're not willing to use your automatic setting, you should remember the old Kodachrome rule of thumb: 1/125 between $f/8$ and $f/11$ in sunlight should give you good slides every time. If the subject is pale, or if there is water or bright sand or snow, go to $f/11$. If the sun hides a bit behind lacy clouds, go to $f/8$. But the ball park exposure of 1/125 between $f/8$ and $f/11$ should be your mental starting place. This means, of course, that you can go to 1/250 at $f/5.6-8$, 1/500 at $f/4-5.6$, or 1/60 at $f/11-16$.

Speaking of that 1/60, why not shoot that slowly as your subjects race around you? The movement will blur the background, and if you move at the same speed as your subject, your subject will be sharp. This, by the way, is the same technique you would use to stop a racing car or galloping horse.

As noted, the greatest failing of the new sports photographer lies in missing the action close-ups. This is where the telephoto or zoom comes in handy.

A mandatory project, at least for several frames, is shooting children's portraits in the shade. Let the sun pour down on your subject's hair and back. You expose appropriately for that nice skin tone in the shade of a bright day.

If there is a light-colored building nearby, use this to bounce some light onto your subject's face. Take your exposure readings—with your camera's meter and a hand-held meter if you own one—from the face. Let the hair with the sun in it take care of itself. Just concen-

trate on reading the face and you will always get good outdoor portraits. Generally, shooting at 1/125 at *f*/4–5.6 will take care of more than half your outdoor portraits in good light! But be sure to use that meter and the one on your camera. Refine your exposure so that when you're out in the field, you will be able to get exactly the effect you want by knowing in advance what it is, not by guessing!

Before searching my own experience in covering various modern sports, I called an old friend, *Sports Illustrated's* picture editor, John Dominis, and asked him for some words of wisdom. He spoke of his magazine's quest for "world class pictures" and of capturing a world class athlete in the right instant, with the right light. This wonderful moment when everything goes right between subject and photographer, Dominis says, results in "a great photograph, a work of art, and a record of a moment in history. The sports photographer must remain as cool as a veteran quarterback, consider all the possibilities, and calmly react at the *right* time with the *right* lens focused on the *right* spot."

He goes on to say that although *Sports Illustrated* photographers have access to much sophisticated state-of-the-art equipment, "it is well within the ability of the serious amateur photographer to take pictures with a good camera and telephoto lens at a high school or college event."

Sportshots, which prints pictures of various sports along with advice from some of *Sports Illustrated's* photographers on covering these sports, is distributed by Vivitar Corporation; however, an honest disclaimer notes that the booklet pictures "may not" have been taken with Vivitar equipment. But they could have been. As I mentioned before, the great photographer Steichen said, "No photographer has yet exhausted the possibilities of the box camera." Of course you have to get awfully close to the players with that box camera.

HELPFUL HINTS

• Practice using your camera without film in it. Make sure your batteries—those working the meter and the motor if you have one—are alive and ready. Aim at, focus on, and track

with your telephotos to get into the swing of shooting sports at the event, when you'll use film.

• Clean your lenses of dust and smudges. Remove them from their cases and check that back element. A greasy thumb mark on the rear element will give you an unwanted softening of your image. Because this grease mark is closer to the film plane, and because that rear element is usually smaller in area than the front element, you should get into the habit of cleansing this rear element first. Sand and salt water are the greatest enemies next to the straight, careless drop of the camera.

A clean lens deserves a clean eyepiece and mirror and a dust-free camera interior. That thread or strand of hair wedged into the camera near the film plane could result in roll after roll of pictures with that thread or hair immortalized on each frame.

A honeymoon couple I know took a new camera to Hawaii and were amazed when each of their hundred frames contained an overprinting of Canon's Japanese letters. They had neglected to remove the transparent plastic sheet on the film plane!

• Take more than "enough" film. Six rolls of black and white and six of color is a modest amount. You can always use the unused rolls, within the year and a half expiration date for color, and up to two or three years after the expiration date of black and white. You will never be sorry you took along too much film, but you will find it hard to forget the time you ran out of film in the last quarter, inning, or set.

• If you are trying to become a professional, or you are on good terms with a school's athletic department and can promise them some free pictures, it's a good idea to call the athletic publicity office and ask its staff for permission to cover a specific event.

Most teams, professional and scholastic, like having their events photographed by almost anyone. (For years before Roger Baldissari became Notre Dame's publicity director, that colorful school would freely distribute sideline passes to almost anyone with a newspaper connection—even to high school newspapers. The result, along football sidelines, was an absolute army of so-called photographers with

box cameras and Instamatics, getting in the way of the professionals. The more crucial a game or event, of course, the more difficult it will be for the noncredentialed semiprofessional photographer to get in.

If you are a high school student trying to cover a major league baseball game, work up an assignment for your school paper or local paper, promising the publication a story. You might do a little feature on pregame activity or sidelines activity—what gymnasts do to warm up—or perhaps a feature on the different styles of foul shooting. Then you can explain to the team publicity person, in all honesty, what you would like to do. As you become more proficient at getting in and at shooting sports pictures, you can work toward the ultimate—a spare ticket for an assistant. Best of all, if you carry lots of gear, you can get a parking pass near the press gate!

● If you have to shoot from a seat that you pay for, make sure you get a seat near the main action or, at any rate, within the capability of your lenses. Many great sports pictures have been made from grandstand seats. One famous sports photographer used to pass out two or three automatic Foton sequence cameras to bystanders who looked trustworthy and tell them to shoot when they saw a play coming close. This photographer was once credited with a great sequence on a crucial triple. His planted camera got the ball going past the outfielder, while his own camera got the play at the plate!

The long zoom, especially with the new breed of extender lens accessory, makes it possible to shoot from almost anywhere you can see.

● If you are on a sideline, or in a designated area for photographers, obey the few rules that most teams establish, either verbally or on a sheet of paper that comes with your ticket. Generally, tripods are discouraged on sidelines. Motor drives and noisy shutters are forbidden close to the players on golf courses. Camera blimps—sound-insulated coverings—are available for still cameras, having sprung from movie camera blimps that keep microphones from hearing the whirring of the movie camera gears.

● Try to get along with the guards at most events. They have their jobs to do, and a wiseacre generally comes off second best to these generally serious people. If an official or guard asks you to move, comply graciously.

● Don't keep popping your head or camera rig into the field of view of other photographers. This is the hallmark of the amateur. Your apology won't square things with the boss of a professional who has missed a crucial picture.

● Don't engage professional photographers in technical discussions while they are working. Wait for intermission times or for a signal that they are agreeable to a chat. Most pros will be very polite about the whole thing and are so adept at their jobs that they can work and also do your metering for you—but it's unfair to them.

● Use your camera's meter and a hand-held meter to check it against. Shoot some test rolls before a game, using the meters in tandem, until you are confident of your exposures. Self-confidence is your greatest ally, and this comes from testing and experience.

SPORTS KNOWLEDGE

The chances are that as a budding sports photographer you have an interest in at least one sport and are conversant with its terms and procedures. Most Americans know something about football, so let's use this sport as an example.

There you are with a valid sideline pass, following the play up and down the field. You will notice the cluster of professionals and advanced amateurs lining up a few yards behind the defense on the sidelines, aiming at the offensive quarterback—usually with a medium zoom lens or a 300mm telephoto.

You may already have a dozen good frames of the quarterback barking signals and of the halfbacks coming toward you trying to turn the corner. You decide you want to shoot a pass reception or interception. You should know who the hot receivers and defenders are. You should sense when a pass play is coming up. You should know when to break away from the cluster of photographers and race to the area just past the end zone, and wait for

the onrushing team to score or for the defense to make a great goal line stand.

The point is that you must develop a feel for the flow of the game, for a team's stars, even for the colorful coach who agonizes on the sidelines or hectors the referees from the sidelines.

A sports event is like chess at high speed. The players make a move. You make a move. They anticipate and think, and you must do the same thing. Know your sport!

If you are going to cover a left-handed home run hitter, the chances are that you'll want to set up near third base—in an aisle, over the dugout, in a box seat, anyplace that lets you get a clear view of the hitter's face as he swings. Use a program as a guide to the batting order. You may have to shoot a right-hander and have to plan how to race from the first base side to that third base side. If you're covering a great outfielder, you might want to shoot from the grandstand or bleachers.

The timing of track event starts has a rhythm you should become familiar with through practicing to help you get those great start pictures. The same goes for swimming events.

Since I believe that animal pictures, even at the zoo, are sports pictures, I recommend that in covering animals you learn their feeding times, their swimming schedules, if predictable, and whatever else you can. All the advance knowledge you can glean defeats the greatest enemy of the sports photographer—fumbling!

In between shots focus on your athletes or animals as they move around. This tracking of moving figures will pay off whether you shoot skaters, soccer players, swimmers, pole vaulters, or chess players. The new ED-type lenses, eventually to be offered in less expensive form, allow this kind of zap or instant focusing by flipping one element of the lens rather than racking an entire lens mount out and back. But the lens itself doesn't matter. It's what you do with it. And what you must do is to learn to focus on that runner fifty yards out and keep the camera focused on him or her all the way to the finish line. Thus, if the runner stepped in from the crowd for the finale after not running the entire distance, you may have a scoop!

PREGAME SHOOTING

Many a full-page picture or cover has been shot by a photographer before the game or event even started.

Baseball players, except for a few temperamental types or pitchers on the day they're pitching, are easy prey for the lens before games. Practice is only lightly organized and practice sessions are long. There is also much waiting around—waiting to get into the batting cage, waiting for the other team to finish, and so on.

With sunlight pouring down, it's difficult to get good light on the face of a camera subject, say, when he's actually at the plate. If you need a good close-up trading card–type picture, here's your chance. Try your small electronic flash on several of these pregame close-ups and you'll never leave it home. Just experiment with its distance from the player.

If the ordinary Kodachrome 64 exposure reads 1/60 at f/8 and your automatic strobe also gives you f/8, stop down one stop, to f/11. Or halve your shutter speed to 1/125 second and stay at f/8.

It would be wiser and safer to use your small strobe on the nonautomatic setting. However, this would involve establishing a guide number for it. The average four-battery small strobe unit provides a guide number for Kodachrome 64 of approximately 50. You divide your distance-to-subject into this guide number—say, five feet. This gives you f/10. But there's daylight on your subject's face, except in the eyes where you want it. So you stop down to f/12. But wouldn't it be easier if you did a test with your own strobe, used your arms spread wide as the distance from nose of subject to flash at camera, and established your own exposure for your own unit? The one thing most amateurs and many pros never seem to get around to is testing their equipment in this simple way. Is it easier to carry two $400 strobe meters?

Most teams permit some wandering around by photographers before an event. However, stay out of the way of special squads and other obviously intense activity. The quarterback throwing warm-up passes makes a good close-up. The coach briefing the star may be easier to get before the game than on the sidelines.

The mascot may be prancing, the cheering squads practicing. The swimmer doing an effortless seal-like turn while warming up may be easier to get than during the actual event. The same applies to divers, close-ups of soccer players heading the ball, tennis players, and, especially, golfers.

The old rule of shooting with the sun flooding light on the subject should be broken by the would-be sports photographer. Backlight or crosslight generally makes for more dramatic sports pictures. Care must be taken to expose correctly for the shadows. The highlights will take care of themselves.

TIPS FOR COVERING SPECIFIC SPORTS

Archery

The colors worn by the participants cry out for color coverage. Competitive archers wear patches that are themselves miniature works of art. The archery gear—pulleys, bowstrings, fletching—all vie with the concentration on the faces of the archers for good pictures. The telephotos are useful for the close-ups and macro-capacity zooms, and normal lenses with close-up filters are fine for the detail shots. Try a fake shot of an arrow going through the air (shot slowly) with the background blurring as you pan with the arrow. Have a co-conspirator toss the arrow into the air, nearing the target.

Auto Racing

Whether you are covering racing at Indy or stock car racing, it's a good idea to pan with the moving vehicles, keeping the car sharp

and letting background and foreground blur. The 300mm lens with extender can help you get close in. It's often possible to shoot good informal portraits of drivers and cars before the race starts or during practice runs.

Baseball

Stay as alert as the players. Keep that zoom lens focused around the 200–250mm zone at a good average position, such as on the pitcher or batter. Your focusing adjustment for infield plays should be minimal. Generally, the best grandstand positions for baseball are behind first base and behind third. The cliche shot, stealing second, is still exciting and calls for a 400mm lens. A long telephoto—one of the new lightweight, short-bodied catadioptric (mirror) lenses—is great for covering outfielders or those fans fighting for a home run ball.

Generally, the automatic meters work well

Whether you can get onto the field pregame or have to work from the grandstand, baseball offers sufficient variety for all approaches.

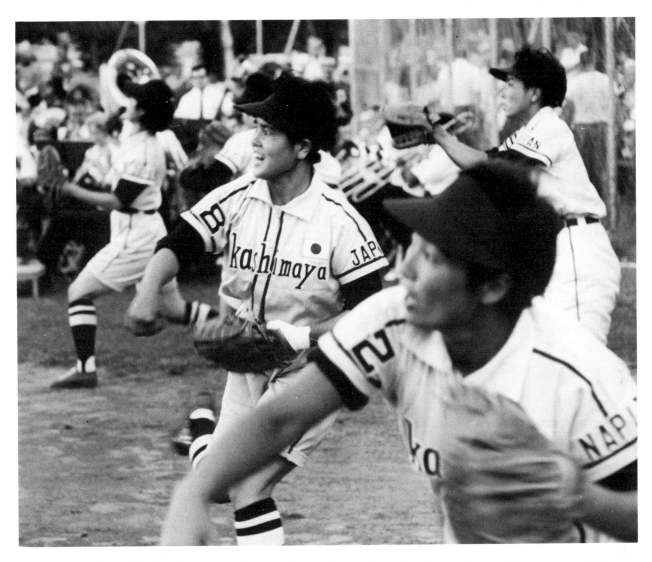

Warm-up sessions offer the alert sports photographer a chance to capture the excitement of pregame activity.

for baseball, because you are usually shooting into the stands as a background. If the infield is in shadow, you should open up a stop or fool your meter by programming it for a slower film than you're actually using.

For night games, the 180mm $f/2.8$ lens made by numerous manufacturers is fine. The expensive 300mm $f/2.8$ has become a standard among pros for night baseball. Canon's new 400mm $f/2.8$ will give Nikon's 400mm $f/3.5$ a run for its money—over $4,000! It costs as much as a good used car, but if you use it right, it will pay for itself.

Basketball

Most teams like to huddle photographers several feet behind the boundary line and to one side of one of the goals. Like almost all basketball pictures, these photos come to have a sameness that can sometimes be avoided by getting into the grandstand with a telephoto or getting into the rafters overhead. Or you can mount a camera behind the backboard and trigger big strobes in the balcony from a Hawk-type radio control. Most electronically flash-lit basketball pictures involve a strobe technician's setting up that main light and the backlight. Kodachrome 64 is generally used for 35mm cameras. Many photographers like to use a 2¼x2¼ square film for these, along with the high-speed front shutters these cameras have. This cuts out ghost images and

blurred arms and legs. Natural light pictures are usually shot on tungsten ASA 160 film pushed one or two stops or on daylight Ektachrome 400 pushed one stop to ASA 800. Most basketball action can be stopped at 1/250 second. One strobe light on the camera can be used for basic coverage-type pictures—nothing aesthetic—especially in a poorly lit gym.

If there are no other photographers around, you might try setting up a slave light aimed directly at you to backlight or halo players coming in to shoot. However, any other photographer with a flash can fire your strobe, making it unavailable to you until it charges up again.

During warm-up, be sure to catch the team's stars shooting foul shots.

In general, for black players under natural (tungsten) light, open up half a stop for better skin tones.

Under the basket the 35mm, 50mm, and 85mm are fine. For shooting action at the far basket, you'll need the 180mm $f/2.8$ or the 300mm $f/2.8$.

Bike Racing

Daytime bike racing doesn't pose many difficulties. By panning with your riders, you can stop them in their tracks, or seem to, at 1/125 second. On a dimly lit track at night, you can try shooting at 1/60 second if you get into the rhythm of swinging the camera at the same apparent speed as the passing bikes.

Boating

The zoom and telephoto are superb for shooting boats other than the one you are in. Boating pictures in black and white lend themselves to experimentation with filters.

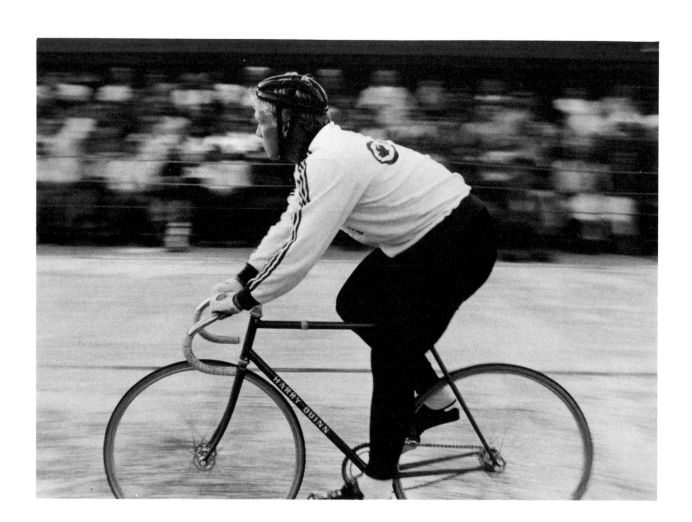

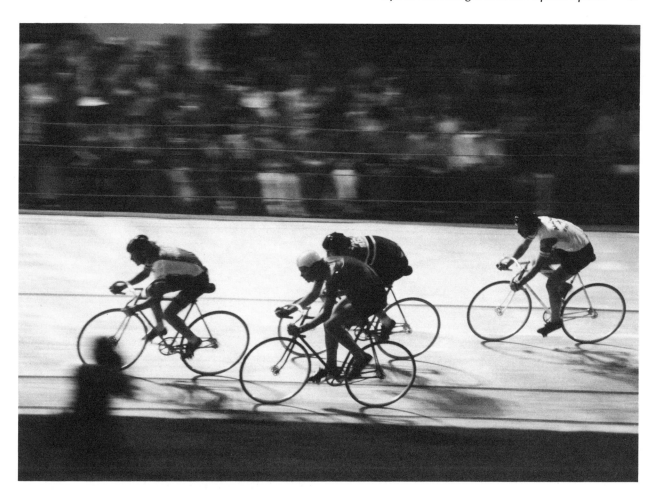

The dark yellows, oranges, and reds give you ever deepening sky tones, making sailboats and other bright craft stand out beautifully and with great contrast. The Polaroid filter is valuable on the water to deepen colors and cut water reflections.

Sophisticated photographers should try shooting a sailboat race from a helicopter. The $150 or so an hour is worth it. Those sails balloon out, you can achieve perfect position, and, if your pilot isn't experienced, you can incur the wrath of captains who think (perhaps with justice) that you are altering the winds hitting their sails. Keep your distance. In general, you should close your lens down half a stop to a full stop for water pictures. The water reflects a great deal of light. Override your automatic camera or just close down a bit from your hand-held meter computation. (Unless, of course, you are a great meter-handler and have already figured in the reflection factors of water, ice, snow, and sand.)

Bowling

Flash is taboo at a bowling event. Posed bowling pictures can be taken during practice sessions by pros and at other meets. The best place to shoot from is an end alley, with the clubhouse wall at your left or right. From about fifteen feet down the alley on the side channel you can capture the bowler in full stride. Prefocus on the foul line and shoot as the bowler's front foot slides up to it at release. Alleys are generally dark. With the action coming right at you, 1/125 is an adequate shutter speed.

Boxing and Wrestling

If you can get close to ringside, these are two of the easiest sports to photograph. Even if you're limited to a seat in the boonies, you can easily enlist your telephoto for a closer view of the ring. The overhead lights are

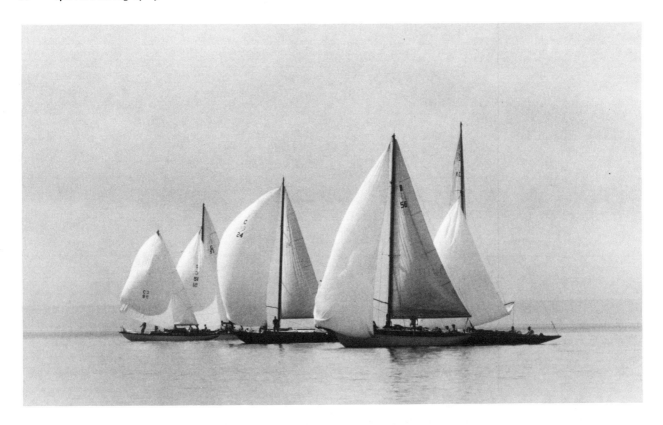

usually tungsten and are sufficient even for action color with Ektachrome 160 pushed a stop to ASA 320. (This should let you shoot at 1/250 at *f*/2.8, with that nice white floor bouncing light back upward at the subjects.)

You've probably seen the ringside scramble of still photographers on televised bouts. It really is a madhouse down there. Motorized cameras whir, and long roll cameras are used by some magazine photographers so the photographer isn't caught without film. Wide-angle lenses—often the pro's favorite, the 28mm—can be used without even looking through the finder. The really big bouts usually find speedlight technicians crawling over the ring canopy a couple of days before the bout, mounting big strobes. Wires or radio controls are then used by the photographers for their coverage. If you're new to wrestling coverage, be sure to find out which side or sides of the ring the behemoths (professional division) use to expel victims from the ring. Otherwise, you might end up with a 300-pounder all over you, as almost happened to me one night at Chicago's International Amphitheatre.

Amateur or Olympic-style Graeco-Roman wrestling is relatively easy to cover. The contestants like to stay near the center of the mat. The light isn't generally as good as it is for pro matches, but the pictures are exciting. If you can get into the pro dressing rooms for wrestling or boxing, you should mount your widest-angle lens and just work on the characters who abound.

Camping

The outdoor explosion of campers continues unabated. A half hour spent with any issue of *National Geographic* will give you an idea of the high state of the art of shooting along the trail, and this should inspire you to look a little farther away from your hiking or camping group. That is, picture them with good background scenery. If you've carried along a small tripod, be sure to self-time some pictures of yourself with your friends. If you are a loner, include yourself to give the scenic view a sense of scale. The SIMA Company (which, as previously noted, manufactures those lead bags that fight off X-rays at the

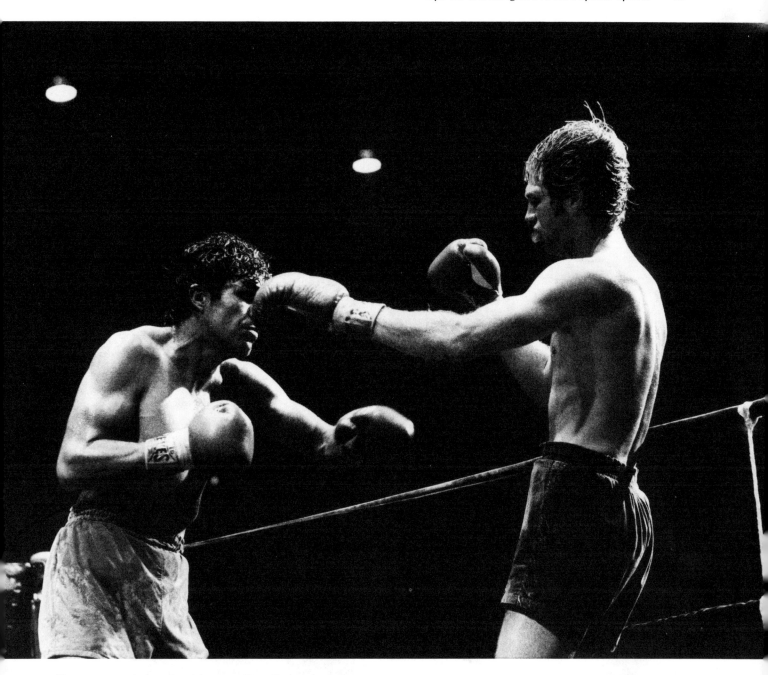

If you can swing a ringside seat, fine. If you can't, you can still use your telephoto zoom to good advantage. The hard action of boxing is generally possible to capture at 1/250 second, as Ken Love did here.

airport) makes a fine little blow-up case that is waterproof, can hold a camera or two and a couple of lenses, and can hitch up to a back-pack or harness.

Field Hockey, Women's

The pleasant explosion of women's sports gives the would-be sports photographer an entirely new world to explore. The bright uniform colors, the flying hair, the unfamiliar expressions of great exertion—all contribute to the fun and artistry of photographing women's sports.

The medium zoom lenses—70mm to 250mm, including the zooms of somewhat shorter ranges—are especially useful for pho-tographing the offensive team charging into a goal. You are looking at the shooters, passers, and the frantic action that goes on in front of

You can also take good pictures before the match. Characters and situations abound around a fight. Lighting is generally superb.

Rule of thumb: panning with almost all sports action, including animals and kids cavorting in the backyard, will give you something a full class up from standard sports snapshots.

Most team or playing field officials won't mind your setting up around the goal, safely off the field.

It's good to remember that many great sports pictures are taken just *after* some wild, successful, or unsuccessful play. There is that moment of triumph—the team in its exuberant hugging, the despondent goalie, the fan who leaps into the cluster of his or her heroines!

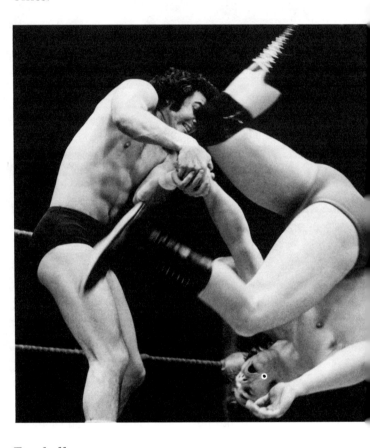

Football

The 300mm telephoto and the 75–200mm (or so) zoom lenses are fine for covering football from the sidelines. Most pros also carry a 400mm *f*/3.5, 4.5, or 5.6 to isolate a player—the quarterback, for example.

Most magazine photographers covering a game will also set up a 600mm lens and motor-driven camera at one corner or another of the field to use for showing the offense bearing down on the goal line near which the

the goal. If you focus just in front of the goal and set your basic exposure right, using 1/250 second as a minimum shutter speed, you can follow action through your single-lens reflex finder, pulling back the lens for wide-angle shots or moving it forward for isolated telephotos of the players.

If a player comes across your field, and you're in focus, try panning with the runner. The sharp foreground figure and blurred background and foreground will give you an unusual sports picture.

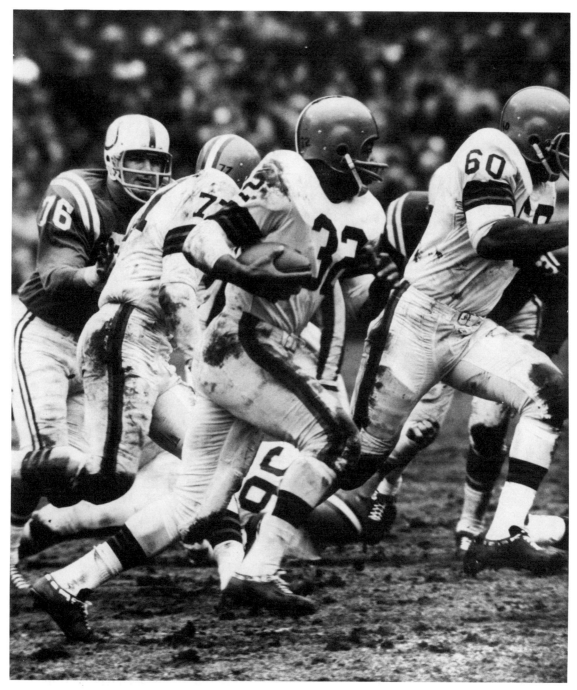

Stay alert for pass plays and sweeps of the line coming your way. Practice focusing for this play before the game, tracking players warming up.

camera is stationed. The long telephoto camera is a problem. Most fields don't allow tripods anywhere near the sidelines and just barely tolerate unipods (one-legged tripods). Management's concern is that a valuable pair of legs—the player's—might get tangled with those of your tripod.

The 600mm or 300mm with an extender, making it a 600mm, can be used near the end zone, deep in the corner of the field.

With the offense driving toward you at the goal line, the short zoom, or 85, 105, or 135mm prime lens, is fine for that goal line stand.

If you're stuck in the grandstand, don't be shy about scooting up and down aisles with your zoom and extender. At 400mm, your extended zoom can cover plays from almost anywhere, as long as you're in the same half of the field as the action. A setting of 1/250 sec-

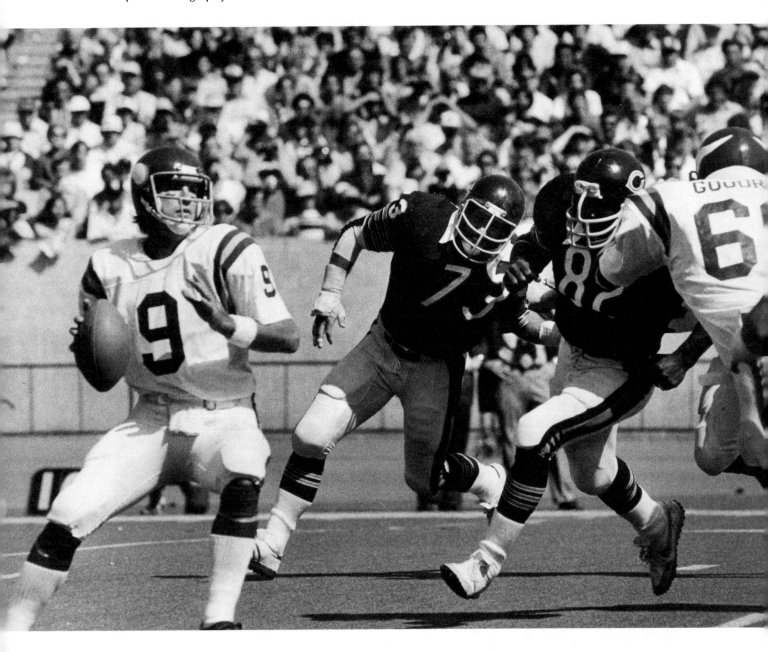

ond is adequate to stop most football action, especially if you pan with a runner.

The toughest football shot to make? The pass reception.

Best way to handle it? Keep the ball in focus as it leaves the passer's hand, and follow it into the receiver's.

Golf

Golf at anything but the pro level is a breeze to shoot. The light is generally good. The telephoto or longer zoom keeps you far enough from the players to avoid annoying them with shutter clicks. Even so, wait until the moment after a player swings or strokes before shooting, especially if you're shooting a noisy motor-drive camera.

Covering pro golf requires good credentials, a lens of at least 300mm but preferably 600mm, and a good map of the course so that you can cut across fairways to pick up the leaders.

For close-ups of the big-name golfers, the practice greens are perfect, if you keep a respectful distance back and don't engage the pros in any kind of conversation. Tip: avoid eye contact with pros in this kind of situation.

They're worried about the coming match. They don't want to lose their concentration by being forced to remember your uncle who once played a round with them in Sacramento.

Expose for the shadows.

Hockey

I have shot championship hockey from behind the goal, behind the safety glass that rings most rinks, through the holes in some of these glass panels cut for local newspaper photographers, and from the balcony with a telephoto.

Modern stadium lighting is just fine for black-and-white photography and adequate for color. The lights are generally a mixture of arc lamps and tungsten lights that balance out as daylight. That is, using daylight Ektachrome ASA 400 pushed a stop to ASA 800 permits you to shoot in most rinks at 1/250 to 1/500 at *f*/2.8.

From high up in the balcony or among the beams, the 180mm *f*/2.8 is an ideal lens as is the 300mm *f*/2.8. Down on the ice the 105mm *f*/2.5 or the 135mm *f*/2.8 is fine for goal action from the sidelines. The latter lens also lets you shoot across the rink into the opposite penalty box. Changing your position to sit on the steps leading to the galleries can give you a different point of view. (Ask the management for a pass that will keep the guards from questioning you every few minutes.) If you're up to ringing the stadium with speedlights and shooting them off by radio, you should close down half a stop from whatever you read on your strobe meter. That ice reflects lots of light.

Hockey is a wild sport. Exposure of 1/250 second at *f*/2.8 will generally capture most action. The ice reflects enough light upward to let you get away with 1/500. Most pros like to position themselves at the boards, a few feet up from the back of the rink, so that they see the goal and can capture goal action and fights around the goal. Hockey is an easy sport for pros shooting slow Kodachrome—the teams don't mind big speedlights going off!

Kids

Kids in action are legitimate sport subjects. Almost everyone, editors included, responds to cute kid pictures—pictures of fun, romping, interrelations, candids. The dad letting go of the two-wheeler with his firstborn learning to pedal for the first time is a fine subject for the sports photographer. "First Bike Ride"—that two-year-old on his tricycle—is a perfectly salable Sunday feature for the local paper. So is coverage of Little League ball or the kids' judo class. The intensity must look Big League and usually does. Try backlight instead of front light, opening up a stop for that self-setting meter. Don't be afraid of water sprinklers and kids with dogs. In the backyard, the wide-angle and normal lenses are the workhorses.

When it's cold out and you've finished shooting snow sports, try a series of household Olympics—kids jumping over brooms, paddling around in the tub, and the like. I've sold this type of story at least three times.

Racquetball, Handball, and Squash

As the official photographer for the U.S.

Racquetball Association and U.S. Handball Association, I've covered several thousand matches played on courts across the country. These are among the toughest sports to shoot in color; they are not very easy in black and white either. Another difficulty is that the best position from which to view racquetball, handball, and squash is from head on, with the players hitting directly at you when you are behind one of the little windows that a very few courts have in their front walls. From this ideal position, with the players serving from twenty feet away and then moving forward or back, the 85mm, 100mm, and even the normal 50mm lenses are useful.

The lower the picture window, the better your action shots will be. One California court has its window so high (it was built for TV coverage) that the game appears to be played by minipeople, and the drama of hard action is difficult to transmit.

With the coming of Ektachrome ASA 400 film, and the ability to push it a stop to ASA 800, has come the perfect film for shooting racquetball in color. (Tri-X and Ilford's HP5 are excellent for black and white, also pushed a stop to ASA 800.) The trouble is that even with a fine front window, the lights are arc

A little imagination helps, day or night. Steve Shay wasn't happy with an ordinary angle on these young moto-cross bikers. He bravely stationed himself under one of the jumps. With a wide-angle lens, he photographed the flying biker passing over him.

The 1/250 shutter speed is fast enough to capture all but a high-speed racquet and ball crossing your line of vision. Racquetball is such a predictable sport—serve, rally, attempted kill, etc.—that it is easy to station oneself along the sidewall glass (if any) or at the backwall glass (if any) and shoot with the 35mm, 50mm, or 85mm lens. Situations to watch for are the occasional leap by one player, instinctively allowing the other to shoot without hitting his opponent. The odd leap, expression, and argument are good for pictures.

lamps. The green cast can be filtered out with a deep magenta filter on the camera, or the best of your green-flesh-toned slides can be corrected through copying by a good lab. The lab copies your slide through a magenta filter. The flesh tones look normal, and you don't lose the full stop that the filter would cost you had you shot through it originally.

At any rate, I experimented with a system recommended by no one. I set up some tungsten-balanced lamps, the kind that would provide good transparencies on ASA 160 Ektachrome tungsten film. This light, combined with the existing arc lamps, gave me a light that balanced almost perfectly with daylight ASA 400 Ektachrome—without a filter! I still use this system to cover important matches. You must make sure that the club's circuits can carry two or three 1000-watt lamps. It will take at least two lights to knock out the greenies.

When a court doesn't have a front wall window, the next best position is up along the right front wall. To shoot from there, you must use a cardboard mask pasted to the glass to cut out overhead and background reflections as you shoot. These cardboards, dubbed *Shay screens* by the racquetball crowd, now appear at every important match.

Another good position is at the back wall. Here a normal 500mm lens or a 35mm medium wide-angle, can cover players as they wheel around to take back wall shots or

When players permit you to use electronic flash or set up floodlights, you are on your way to the outer limits of sports photography.

square off for attempted kills. Good overall shots can usually be made from back in the stands.

Three-wall outdoor courts in Florida and California and the one-wall handball of New York City give you a break on the outdoor light. However, there is no optimum place you can stand for a good three-wall shot. It's

Natural court lights—those accursed arc lamps—aren't all that bad for black and white. The classic 1/250 at f/2.8 with ASA 800 Tri-X applies. Note the difference in shadows and highlights between speedlight picture (a) and natural light picture (b).

best to stand at the rear of the court and shoot players turning back to retrieve long shots.

A shutter speed of 1/250 second is adequate for racquetball, though not entirely capable of stopping hard action.

Arc lamps have a kind of periodicity, like TV screens. At higher shutter speeds you get a dark swatch over some of the white walls. These swatches don't show up on glass walls. Fortunately, most of the big matches are played on glass-walled courts. For four white walls floodlights are recommended. These should be aimed down from the balcony. Two of them usually clean up the periodic darkening of the walls called arc lamp shadow.

A few courts are still lit by fluorescent light. The level of illumination is not very high, but high-speed daylight Ektachrome ASA 400 pushed a stop can be used here. An FLD filter (fluorescent) or 30 magenta filter or gelatin disk help flesh tones by cutting into the greens. What actually happens is that the magenta adds red to the normally red-less fluorescent spectrum.

Skiing

The telephoto lens is the ski photographer's friend. The snow can be friend or enemy. Expose for the faces of the skiers if you want to cover a race. This involves opening the lens about half a stop to a full stop from an automatic shutter reading. After all, the shadowed face needs more exposure than the glistening snow. If you are doing scenics, you probably will have to bracket your exposures, depending on the effect you want. If you are shooting directly into the sun, you'll want to close down a stop from what you would shoot when aiming at a sunlit slope.

Use a basic 1/250 shutter speed for action shots, but pan with skiers going past you. When shooting competitors coming downhill at you, around flags, focus on one flag and shoot as your skier comes into its range. The polaroid filter, cutting down a stop and a half, is useful in ski photography in good light. Turn it and see what you can do with reflections and how well it darkens the sky at certain angles.

Soccer

Soccer is one of the fastest-growing sports, and it is a lot more difficult to shoot than football for a simple reason. Football action moves in rather predictable straight lines. Soccer is a zigzag game. Focusing on soccer players in the field with a long telephoto can be tiring. If you have a 500mm or 600mm lens, mount your rig on a tripod and shoot from one goal at the players coming toward you. Of course, there is always excitement in using a shorter lens—35mm or 50mm—and shooting over the threatened goal at the attacking player or catching the goalie's save. As noted earlier, it might be wise to try a few header close-ups before the game starts, to make sure you get the star header heading the ball close up.

Swimming and Diving

With a telephoto lens, swimming is easy to shoot. If you have trouble focusing continuously on a swimmer, focus on a zone or area—

say, a few feet in front of the wall at which the swimmers turn. When the swimmer comes into range, or a split second earlier, zap! Incidentally, it takes about 1/30 second for the picture to be taken *after* you push the shutter release button. This should help you anticipate your shot a bit. Outdoors, remember to stop down half a stop to a full stop to compensate for reflections. Try panning your telephoto lens as a swimmer comes past you in a

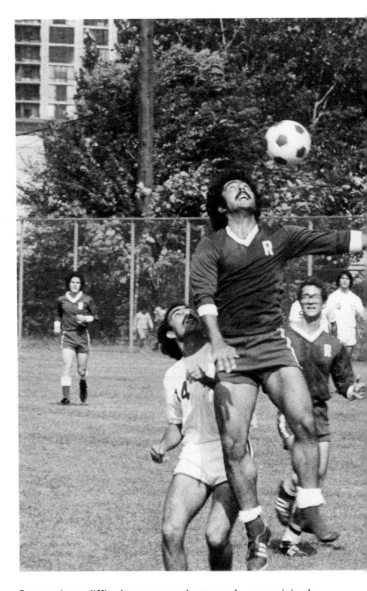

Soccer is a difficult sport to photograph—surprisingly more difficult than football because it is a zigzag game. The trick is to follow the ball with your telephoto. Most soccer clubs permit you to work the sidelines. From the grandstand that 80–200mm lens with extender does a fine job of covering most of the field.

lane. If the meet isn't crucial, you can probably get permission to run up and down the side of the pool following the swimmers or staying apace and shooting them sideways. Experiment with a slow shutter speed—as low as 1/4 second—for this kind of shot, but make sure your lens opening stops down accordingly.

Anticipating and tracking will serve you well as you shoot divers off the boards, the platforms, or the side of the pool. A motor wind or drive will serve you well for diving sequences. During practice, climb up to the high platform and shoot down at a diver stretched out in flight.

The motorized camera is a must for serious diving photography. You must learn to anticipate your subject because the single-lens reflex mechanism requires about a 1/30 second lag between the time you press the shutter and the time the picture is actually taken.

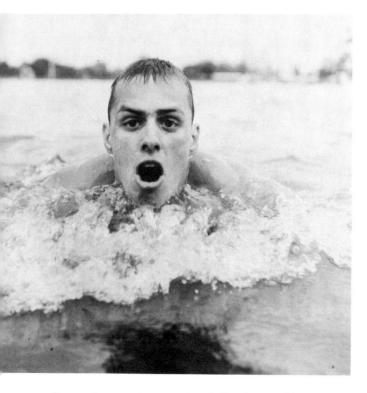

Swimming meets are naturals for the would-be sports photographer. A kind of calm mood prevails, and if you miss a swimmer on one lap, you can catch the next. The water reflects light well. You can shoot from the grandstand or, without much trouble (if you ask the officials), from near the starting line.

Tennis

At a recent tennis match I watched the tennis magazine photographers cover Chris Evert Lloyd and Andrea Jaeger. They used 300mm and 400mm lenses. They were going for smashing close-ups of each player. I was covering for *Sports Illustrated,* and although I joined the group of photographers at the sidelines, first shooting one player and then the other, I soon left the sidelines and went into the grandstand just behind one of the players. With a 50–300mm zoom lens I was able to show the clever fifteen-year-old first outsmarting the twenty-five-year-old veteran, then shoot the reverse. My feeling was that covering a match should show both players in the same picture at some point. Actually, *Sports Illustrated* ended up publishing a picture of both young women together, after the match, holding checks and trophies! So be sure to get the nice, corny "record" shot along with the hard action.

It is wise to try for credentials for tennis sidelines before the match. The safest shutter speed is 1/500 second.

Track and Field

Track and field events are a feast for the sports photographer. Obviously, the finish line is a good place to wait for peak action. But most events, all the way up to the Olym-

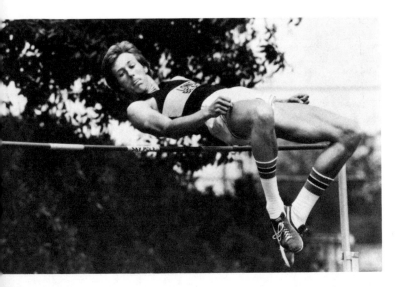

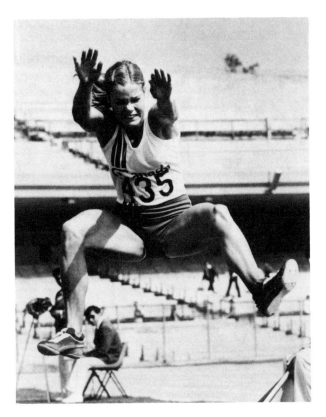

pic level, offer the roving photographer lots of opportunity for varying the approach.

If you move slowly and don't attract attention to yourself, you can move in to short zoom range on the high jump. Practice jumps will give you an opportunity to prefocus on, say, a long jumper—focusing halfway down the pit, waiting for the jumper to reach his or her apex.

The sports photographer working in a new stadium should try a few frames of the facility itself. Often the manufacturers of lights, installers of the seats, etc., are delighted to pay well for pictures of this sort. (See Chapter 14.)

Zoos and Animals

Editors love animal pictures. After pretty-girl, handsome-couple pictures that have a feature angle, editors are most partial to buying a cute animal picture. Zoo animals are easy to shoot with the 80–210mm (or so) zoom lens, especially with a good extender. Bars can be eliminated if they are not wanted. Splashing, snorting, mating, frolicking, and parenting are all grist for the sports photographer's lens. The finickiness of animals makes them fine targets for practicing and mastering the zoom and motor winder. Monkeys leaping from branch to branch, from light to shade, are tough to follow. But when you learn to keep them in frame, in focus, and in good exposure, you can shoot anything that moves.

Don't poke that lens between the bars, lean over moats, or otherwise endanger animals or people. If you have a special problem or project, zoo directors are among the most cooperative people with whom you will deal. Follow through by sending a couple of free prints.

10

Snow and Underwater Photography

SNOW PHOTOGRAPHY

The growth of winter sports is nothing short of phenomenal. The ski lifts from Colorado to the Andes and Gstaad are crowded. Of the more than two million single-lens reflex cameras sold in each recent year, a goodly percentage has been bought by cold weather photography fans.

In general, the new automatic meter cameras work fairly well when shooting snow scenes as landscape views, perhaps with people in the background. The film of choice for snow scenes is Kodachrome 25, which is slow enough to prevent the automatic metering devices from going off the deep end. That is, the film allows these devices to provide camera settings of approximately 1/125 at $f/11$, 1/250 at $f/8$, or 1/500 at $f/5.6$, the latter two for hard action *with frontal light.*

Many overexposed pictures come from using fast film, like Ektachrome ASA 200 or ASA 400 or Kodacolor ASA 400. Even at 1/1000 second and $f/16$, the limits on many cameras, the poor camera has too much light bouncing in off the snow.

When you are shooting skiers or snowmobilers coming at you, and all the light is from the rear or side, you should override your meter's exposure and open up your lens a little less than a full stop, perhaps from $f/8$ to $f/6$. This allows for good flesh tones in the face of your skier, which are preferable to the deep, deep white background and shadowed, underexposed face of your subject.

Special care must be taken around snow, as around sand and water, to keep the lens and camera moisture free. This may involve such heroic measures as wrapping everything but the front surface of the lens in plastic, especially during inclement weather. Several ingenious photographers have adapted harness-type gear to carrying cameras on ski or snowmobile trips. It is possible to carry two motorized cameras with short or medium lenses on such a body rig, plus a small bag that is useful for carrying film or a polaroid filter.

The latter is a useful tool for shooting snow or water sports. It is dark gray-green in color, and rotates so you can view its effect on sky, water, and snow, watching how it knocks out

Technique aside, snow offers compositional glories—mountains, skiers, and people in the foreground or background.

It's wise to use a medium yellow filter, as in this Colorado mountain scene. The filter lets the clouds show up. A red filter would exaggerate them. An orange filter would make them somewhat darker. No filter would permit the sky to overexpose itself, resulting in sheer white or almost sheer white. A polaroid filter is useful in snow scenes.

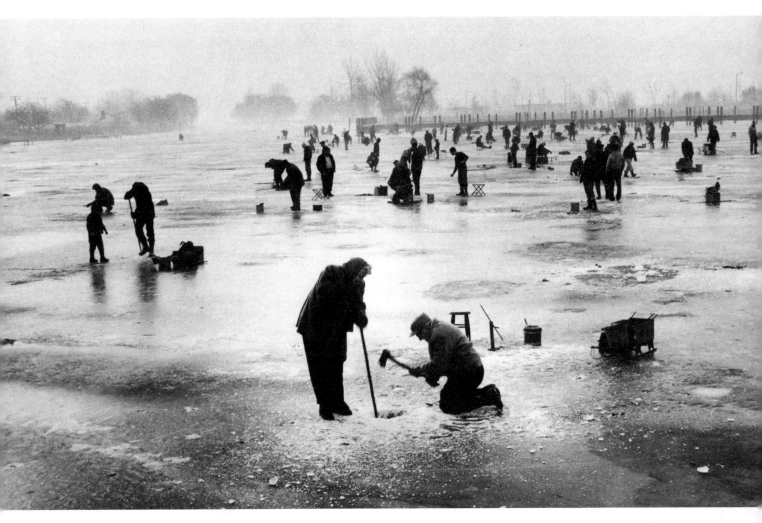

Ice anglers are so intent on their sport that they rarely look up; they are a joy to photograph. Keep in mind the reflectivity of the ice, stopping down half a stop to a full stop—just far enough to retain some detail in the faces that are in shadow. Luckily, black-and-white film is amazingly forgiving. It's almost impossible to lose out completely shooting black and white in the snow.

reflections and darkens skies. It costs you two stops of exposure, slowing you down from, say, f/11 to f/5.6. But it sure darkens those skies, cuts glare on glass and ice, and protects your lens.

By using a slow shutter speed—1/30 or 1/60 second—and a polaroid filter (or neutral density filter that cuts down the amount of light coming through the lens but has no polarizing effect on reflections) you can pan, that is, swing the camera and lens along with a moving skier, snowmobiler, iceboat, or racing car. If you shoot a sufficient number of frames, you can get pictures in which your subject is relatively sharp and the background appears to be blurred. The effect is one of high speed action, of course.

Not panning the camera at 1/60 while sighting at a fleeting subject will give you a mere blur of the subject and leave the unmoving background still.

UNDERWATER PHOTOGRAPHY

Whether you use a self-sealed underwater camera such as the Nikonos or one of the elaborately engineered sealing housings for specific cameras, such as Rolleiflex, Hasselblad, and others, the variables in taking good pictures are much the same as they are on land. There is one additional variable—refraction. Refraction is the optical phenomenon that bends light rays as they pass from the air into the water or from the water back into the air. (The phenomenon of bending occurs because light travels faster through air

A rule of thumb when shooting underwater in clear water with sunlight pouring straight down or nearly so is to use f/16 and then use the shutter speed closest to your film's speed.

than it does through water.)

For practical purposes, refraction makes objects observed by the eye and camera *seem* to be about three-fourths the distance they actually are from the viewer, that is, somewhat *closer* than they really are. If, for example, you are photographing a wreck that's actually sixty feet away, set your camera at forty-five feet.

Assuming a flat-surfaced viewing port of glass or plastic, when shooting underwater, the average camera lens will cover about three-fourths of what it covers on the surface, in the air. The wider the angle of the lens used, the more edge distortion and color falloff or misreading will occur around the edges of the picture. This effect is negligible in most underwater shooting, and some photographers even like the look a wide angle lens gives!

There are, however, domed or curved ports, some working as auxiliary lenses for very wide-angle lenses, which correct the distortions.

The best introduction to underwater photography for the novice sports photographer is probably the Nikonos camera with its 35mm wide-angle *f*/2.5 lens made by Nikon. Most rental houses rent this camera with or without a flash or speedlight attachment.

The ingenious method of making this camera watertight, and its overall watertight front skylight filter make it a popular all-weather camera with magazine and news photographers who must work in the rain, snow, or muddy areas. When finished shooting, you just wash the camera under the water tap!

Bracket your exposures until you get the hang of it or become a serious underwater photographer and get into meters and snorkeling gear. Minolta's miniature (110) Weathermatic is waterproof down to fifteen feet.

The Nikonos has interchangeable lenses, but the normal wide-angle lens should serve as a fine introduction to the apprentice underwater photographer. (Nikon makes UW lenses for underwater work of 15mm and 28mm for this camera. These lenses work fine underwater but produce blurry images on the surface.) The 35mm $f/2.5$ and the 80mm $f/4$ can be used on the surface as well as underwater. The Seacor Company makes several "Super Eye" glass domes that permit the use of Nikon's fish-eye lenses underwater.

Aqua-Craft makes some accessory lens attachments called "Green Things" that increase the angle of coverage of the various Nikon lenses for the Nikonos. *National Geographic* developed its own camera enclosure for undersea pictures.

As on the surface, exposure is one of the port photographer's main concerns. Water is about 600 times denser than air, and light coming through water bounces, refracts, and, in general, blunts its sharp above-surface character when it ducks underwater.

When the sun shines straight down onto a calm surface, about 90 percent of the light is transmitted into the water and begins to fade as it descends into the deep.

Various underwater meters are available. Ideally, one should dive with such a meter securely strapped to the body and use it as a reflected light meter. You should measure the light actually bouncing off a subject, if possible, or off the hand, if the hand approximates the reflectivity of the subject.

Around noon, with the sun approximately overhead, the light underwater will be at its greatest intensity, pouring straight down through the water. On a clear sunny day, between 10:00 A.M. and 2:00 P.M. with an underwater visibility of fifty feet in a slight wind, Kokak's useful *Underwater Photography* pamphlet AC-25 recommends the following rule-of-thumb exposure adjustments.

Take a reading on the surface with an ordinary light meter. Then compensate by adding exposure, opening up your lens or decreasing your shutter speed proportionately, as in the chart below.

Since 1/125 second is the most commonly used underwater shutter speed (1/60 is fine if you're standing still and your subject is placid), you must seriously consider the use of artificial light—flashbulbs or speedlight.

In general, no matter what speedlight or flashbulb you use underwater, *your above-water guide number will have to be divided by a factor of three to get good underwater exposures.*

Up to twenty feet down, in good sunlight, black-and-white Tri-X, Ilford HP5, or similar ASA 400 films will usually give you good exposures at 1/500 second between $f/11$ and $f/16$.

Depth of Subject	Increase Exposure over Surface Reading
Just under surface	1½ stops
6 feet	2 stops
20 feet*	2½ stops
30 feet	3 stops
50 feet	4 stops

*Below 20 feet, a flash is a must.

Kodachrome 64, the world's most popular transparency film for reasons of quality, does well at 1/125 at *f*/8. (Remember the old rule for on-land shooting: Kodachrome 64, in *average* good sunlight, can always be depended on at 1/125 between *f*/8 and *f*/11. At dockside, or for other bright subjects and in beach or snow scenes, you can safely try 1/125 at *f*/11–16. Thus, underwater, Kodachrome 64 at 1/125, *f*/8 compensates somewhat for the underwater dispersion of light.)

Of course, shutter or aperture preferred automatic cameras, in suitably designed underwater housings, will set themselves quite accurately underwater. If you trust this kind of exposure system on land, you can be confident of it in the water as well. Naturally, shooting into the overhead sun from underwater offers you the same complication underwater as it does on the surface. Thus, you might want to adjust the camera accordingly, to open up for subjects between you and the brilliant light source. The easiest way is to fool your camera's automatic meter by setting ASA 25 into the system when you are using ASA 64 film. This will give you an extra stop and a fraction and will overexpose the background glare of light, but it will also punch detail into those shadows. For example, it might give you bathing suit detail rather than silhouetted figures, if this is what you want.

It is important to remember to reset your film data once you have finished shooting into the light.

Filters

As the eye soon avers, it is awfully green underwater. The most useful filter by far for color shooting is the CC30R, a reddish filter that compensates for the green. This correction costs you around half a stop in exposure but is worth it if you're going to shoot lots of slides.

More than twenty feet down you might want to add a light yellow (10 Y) to your CC30R or use a Seacor Sea Filter 1V, which is magenta-yellow. A slightly warming 81A filter is used by some heavy underwater shooters, taped to their strobe light window. This balances out some of the blue-greens that come with electronic flash at medium levels.

Just as blue skies can be darkened with yellow to orangish filters on the surface with black-and-white film, underwater areas of deep blue can be similarly darkened, helping you concentrate on your foreground. You must generally allow nearly a stop for these filters, so be sure the expected effect is worth the loss of shutter speed or aperture.

Bluish filters, of course—even the light Kodak photoflood correction 80A series—will darken that blue background.

Underwater photography is a highly developed art, and fantastically beautiful work is done by a small elite corps of pros. *Skin Diver* magazine (8490 Sunset Blvd., Los Angeles, CA 90069) is a source of current information for would-be underwater-sports photographers. So is *Underwater Photographer* (Box 608, Dana Point, CA 92629).

Underwater with the Nikonos & Nikon Systems, by Herb Taylor (published by Amphoto, New York), is the best of the many general books on underwater photography. It is simple, covers the entire field, and doesn't concentrate on a plethora of beautiful pictures that leave little room for the kind of information a new underwater shooter needs urgently.

11

Common Mistakes and How to Correct Them

Many of the fine books on sports photography that I've seen, use color pages as a smashing display of great pictures. This is aesthetically pleasing to almost everyone. The point, however, is not to please, but to transmit know-how to help the sports photographer improve his techniques.

In the section that follows, I have gathered together many bad pictures and a few good ones—embarrassing mistakes and just plain mistakes. Wherever possible, I've tried to explain what went wrong and how the aspiring sports photographer can avoid falling into similar pitfalls.

The variables of sports photography—light, motion, position, equipment—make it an imprecise art. It is the variables that also open the door to creativity.

My object in publishing bad pictures is to help you think the way some sports photographers do. Almost every rule can be successfully, even brilliantly, broken.

I'm sure that you will want to do this after you've learned the general rules of the game.

Most of the new single-lens reflex cameras, such as those made by Nikon and Canon, have a multiexposure control—a lever or button that permits you to make a series of exposures on one slide. This offers the sports photographer many creative opportunities. Most sports photographers use the multiexposure control to show several stages of fast-moving action, such as a gymnast's maneuver. The temptation for the new sports photographer is to pile up too many images as in the first picture. Of course, rules are made to be broken, but three or four multiexposures generally make the point, as in picture 2. In terms of exposure, just remember to compute an overall total exposure, and be sure to let your multiexposures add up to the original computation.

That is, if the basic exposure is 1/250 at f/8, two exposures on the same frame should each be 1/500 at f/8. For three exposures on the same frame, 1/1000 at f/8 should be close enough. Working on the photographer's behalf is the amazing latitude of film. It is very forgiving. One stop over- or underexposure won't get you into trouble. Ideally, you should use a tripod for this kind of shot.

Using the longer zoom lenses, or zooms and prime lenses with tele-extenders, sometimes results in crowding too much into a single frame, and often losing a good picture because of it. There are no unbreakable rules of composition in sports photography, but it's a good idea to allow a little breathing room for your subjects if possible, whether you are shooting horses or ball players.

In a still-life sports picture such as that of the horse repeating his image on the van in picture 3, you should also make it a rule to vary the exposure from your meter's or automatic camera's recommendation. Note how the half-stop underexposure (or, at least, variation) improves the color saturation of the horse picture on the right (4). A slight edge for cropping has been left to avoid crowding.

1

2

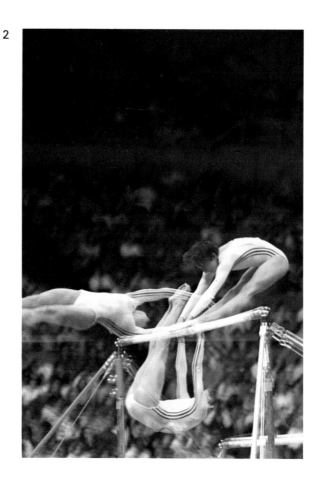

3　4

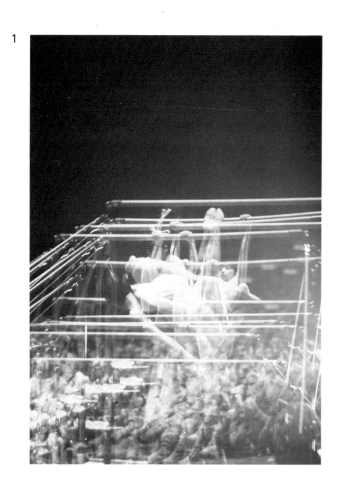

Some of the best sports pictures taken by professionals are well-planned, even posed action pictures. A camera is mounted at the horse barrier, at the rail near the finish line (on the starting car, as in picture 6, in *Life* magazine), overhead in the rafters and tripped by a radio control, or, as in photo 5, on an iceboat mast. The electric tripper wire and switch were taped to the steering wheel. The iceboater tripped his own shutter at a slow 1/30 second. Fine stunt flying pictures—slow rolls, snaprolls—have been taken with this technique. However, the inventive new sports photographer can also use an unusual angle or pose and do almost as well as the professional. That golf cup in picture 7 is a fine prop, especially for a ball photographed at 1/15 second (from a tripod, of course).

Your chance to create an unusual sports picture comes when you start to plan—before going out.

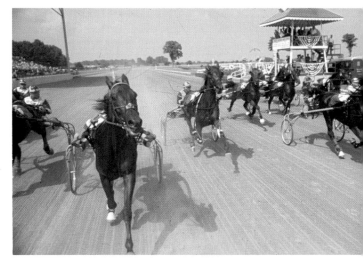

6

5

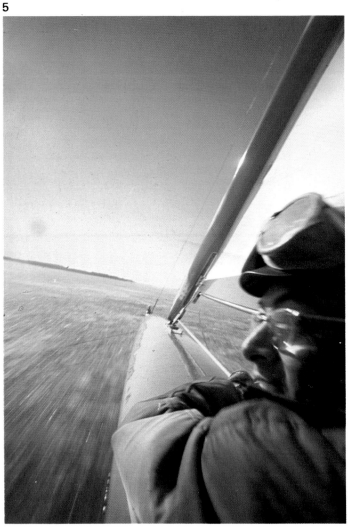

7

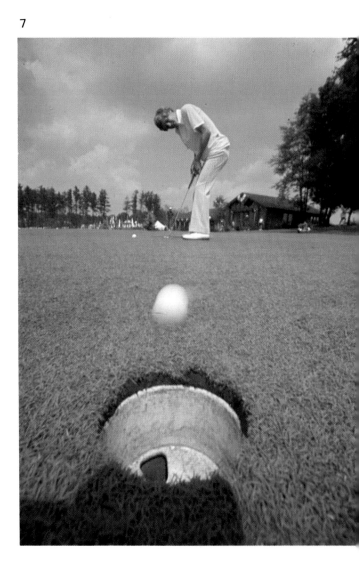

The seductively high speeds available to the modern photographer, with the fast films and motor drives to help, generally result in an initial burst of stop-action pictures in which a moving figure is frozen, usually at 1/500 second.

This is fine for starters, but the beginning sports photographer should not hesitate to slow the shutter to 1/125, 1/60, or even 1/15 second. It may then be necessary to use a neutral density filter or, more conveniently, a polaroid filter. This permits you to lose two stops. Thus, a snow action shot that reads 1/500 at f/16 on the meter can be shot at the equivalent of two stops down—f/16 at 1/125. Without the filter, of course, your frame would be two stops overexposed—awfully white!

The trick is to pan with your subject. Move the camera with your moving subject. The zoom lens is perfect for this. Start tracking your subject just before it comes into the frame and shoot while your camera is moving. This will blur the background. The ski pictures were done as described.

8

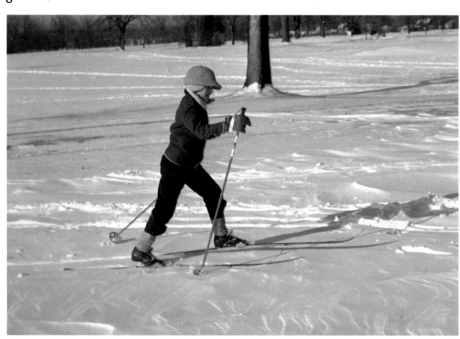

9

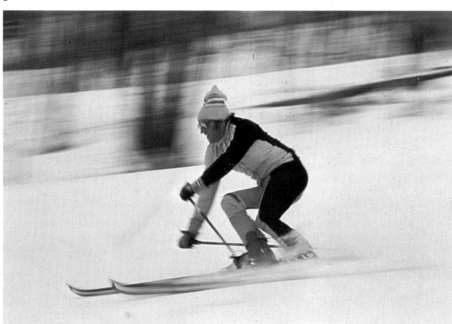

Nowhere are greens move evident than in shooting color without filters near fluorescent lights or, even worse, arc lamps, as demonstrated in picture 10. These terrible light sources (see Chapter 7) can be dealt with to a certain extent. In general, though, it's a good idea for the sports photographer following one or more athletes to carry an FLD (fluorescent daylight) or FLB (for shooting Type B film under fluorescent light). I've found that a pair of Singh Ray filters, which performs the same function, is even better.

Sometimes the arc lamps in the average indoor racquetball court aren't bright enough to allow you to use a deep magenta filter. Just use high-speed Ektachrome ASA 400 and have the lab push it one stop to ASA 800, *but also ask the lab to correct your good slides*. That is, you pick out the good action shots and then have the lab correct the greens by copying or duping the good slides through a magenta filter or whatever filter combination the lab technician thinks it will take to get rid of the greens.

More advanced photographers might want to try several photoflood lights aimed at the court but not too close to the crackable glass. The position of the lights must be chosen carefully so as not to bother the players.

When using 1,500 watts of floodlight, added to the arc lamps, the color balance looks like the picture of champion Marty Hogan at right—balanced for daylight film without any filter at all.

10

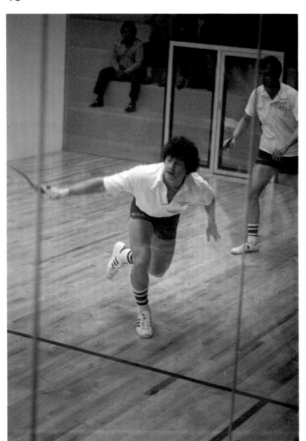

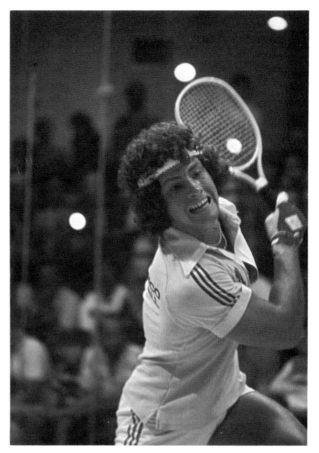

11

By far, the most common cause of blurry sports pictures is camera movement. Your hand shakes, jerks, or lurches as your finger pushes the trigger, especially at speeds under 1/125 second. Triggering a camera for any kind of picture should involve a gentle pressure. Sharpshooters develop the necessary gentle touch after taking a few blurry pictures. A good photographer

12

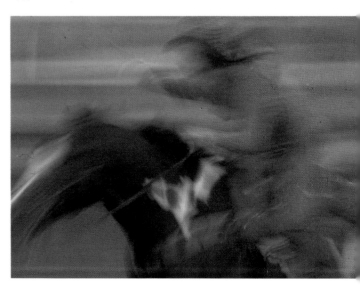

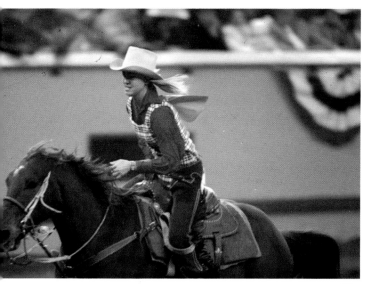

13

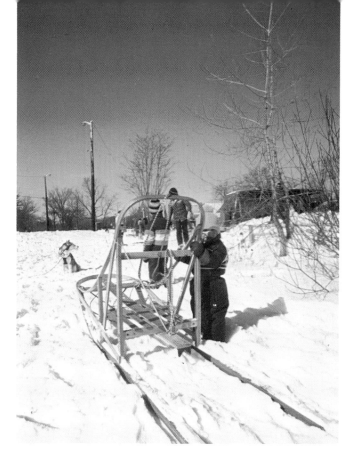

14

should be able to shoot a single-lens reflex camera (with mirror box) at 1/30, with any lens up to 135mm, without getting camera shake in the picture. If this is difficult for you, leaning the camera on a convenient railing, fence, or even the shoulder of a friend will help, short of doing the safest thing of all—using a tripod.

Incidentally, those of you who use Leica range finder–type cameras, such as the fine little Canon QL-17s, Minoltas, Konicas, and Olympuses, can easily become proficient at shooting at speeds up to 1/2 second. Of course, you should try a few frames and get your body well set and comfortable as you gently squeeze the trigger. In minimal light conditions this technique can sometimes spell the difference between getting a picture and getting no picture.

In picture 12, where the camera was purposely panned with the horse and rider at 1/8 second, the blur is different from the blur of camera shake. In this kind of panning blur, there is usually one area, generally near the center (the horse's neck in this case), that is sharper than the rest of the picture. This is because the horse's neck is closer to the center of the lens than are the extremes. Wild variations of this technique involve zooming the lens from out-to-in or in-to-out as you pan.

Another culprit stalking the new sports photographer is overexposure. There is absolutely nothing a printer, engraver, or anyone else can do with an overexposed slide. I'm not talking about cute high-key overexposure for effect. I'm talking about the heart-sinking kind of overexposure that every photographer has known at some time, when slide after slide, ostensibly exposed by meter, guess, instinct, or film directions, comes up a couple of stops too bright, as in picture 14.

Get used to stopping down for the reflection of snow, sand, and water, or at least bracketing exposures to compensate for the danger that too much light will bounce onto your subject from the surroundings.

A spot meter sometimes helps, if you experiment with it and know that you want to expose for that skier's face because you're doing a feature on her—and you don't care if the snow goes whiter than white.

Learn to use the exposure variation dial if your camera has automatic exposure faculties. If you're interested in a pictorial snow photo, you may have to stop down two stops from your automatic exposure meter (built into the camera) reading (similar to the results in picture 15). With the sun in the picture, try two or three different exposures. You won't be sorry.

15

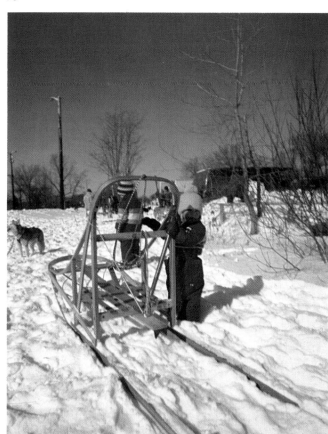

One of the basic rules of all professional photography is: get there early. An early arrival means that you can set up and plan pictures without the clock staring you down. It means you can case the situation. It often means that you can meet your subject and study your problem.

A good case in point is covering a harness race. If you arrive really early, you can take all sorts of interesting prerace pictures. Sometimes an editor who has seen too many hard-action pictures of races will splash a big moody prerace picture across the page.

As will be explained in Chapter 12, shooting sports pictures from the TV screen is not difficult. (Remember, such photos are not for publication! Special permission had to be obtained for using these ABC images.)

A tripod is a necessity, for the best shutter speed to use (for focal plane shutters such as those on Nikons, Canons, Pentaxes, Minoltas, and most other single-lens reflexes) is 1/15 second. The TV image is made up of a large number of lines, and these constantly move in a scanning motion. Thus, faster shutter speeds sometimes catch a partly blank screen, such as the line across the face of my old friend Jim McKay.

Too slow a shutter speed with the lens opened up half a stop too wide will overexpose your frame. Generally, automatic meters do pretty well on TV screen light measurement. Just set the lens so that your shutter is working at 1/15 second. This should give you around $f/5.6$ with Kodachrome 64 (daylight).

If you own a magenta filter, you can tone down a bit of the characteristic green in the image by using a 20 or 30 magenta filter.

In picture 18 a household lamp reflection unnecessarily mars a typical, if not spellbinding, TV action shot.

Rather than do this kind of shooting, it is better to observe sports coverage by the networks. They generally make fine use of long zooms, close-ups, and candid shots of the audience and players when they are off guard. A sports photographer can learn how to cover an event this way.

One of the most exciting days in a new sports photographer's life is the day a long zoom, tele-extender, or telephoto lens arrives and that long Nikon, Canon, Tokina, Vivitar, Sigma, Olympus, Pentax, or any of the other myriad choices is put on the camera. With a tele-extender, the 150mm outside limit of the zoom becomes a 300mm telephoto; the 250mm zoom becomes a 500mm lens. That venerable 300mm lens becomes a wicked 600mm. Of course, you lose two stops, but the baseball pictures above were shot with a 300mm and tele-extender. The f/4.5 lens became approximately f/9, which is fine for ASA 200 Ektachrome at 1/250 on an average day.

Using the long telephoto involves paying special attention to framing, which is more critical with a long lens. A tripod should be used with these rigs, if possible. Minimally, some kind of rail support is helpful. Much more attention has to be paid to the choice of a point of view.

This involves a kind of fine-tuning. Do you want the pitcher, batter, and catcher to show? Do you want the ball in midair? And so on. Telephoto lenses compress distance. The pitcher will seem to be close to the batter, as in picture 20. An extraneous shape, like the red-capped base runner below (picture 19), can spoil the best point of view momentarily. The telephoto perspective should be turned to your advantage.

As Birdie Tebbetts, the great Cincinnati manager, once said to me, "Baseball is a game of inches." This is often very true of sports photography. A few inches of change in point of view, a split second in timing, and the picture is entirely different.

20

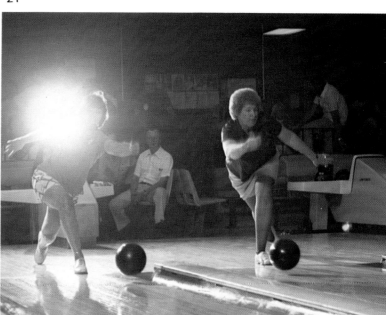

Recently, several disheartening rolls of bowling pictures I shot for *Sports Illustrated* were returned to me. One of my two giant speedlights refused to fire, which guaranteed a dark background unless I came up with some other measure. So I gave two people sitting in the audience two smaller speedlights, asking them to hold them between me and my subjects to give me a dramatic backlight. Disaster! If you can't be sure that your backlight will be hidden by your subject—when you get into advanced lighting—aim the backlight at the ceiling. Also, to avoid unavoidable blinks of an eye, shoot lots of frames!

19

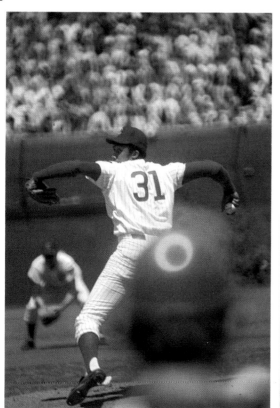

21

Editors love close-up action. They try to crop as tightly as possible, leaving out extraneous material, such as the judges and spectators in picture 22. This is, of course, a matter of judgment. But, in general, the overall picture is used to show the editor the setup, what was going on. The close-up picture is the one he or she will tend to use. So shoot a few overall photos that set the scene, but concentrate on such close-ups as the high jumper in picture 23.

The sports photographer's eye should be a restless instrument and should range way out but zoom all the way back in.

Sports events generally provide some sort of overall pattern picture—the band, the spectators, the costumes, the flags.

Editors often complain that sports photographers don't bring back enough close-ups. The thing to look for is the pattern. As in nature, sports scenes tend to array themselves in patterns and compositions. All you have to do is seek them out and record them. The Big Ten flag formation picture came during halftime.

22

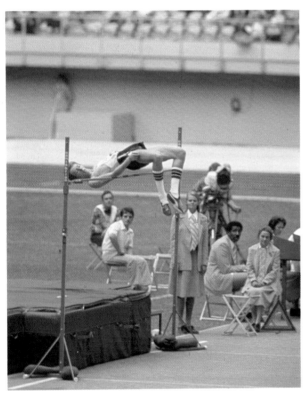

24

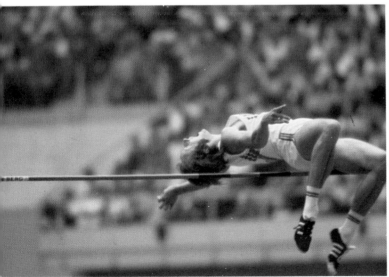

23

Fault	Cause	Correction
Blurry figure	Shutter speed too slow (1/125)	Faster speed (1/500)
Everything blurred, including background	Camera shaken at moment picture was snapped	Steadier hand; tripod; faster shutter speed
Amputated part of sports figure or car	Poor tracking of target	Swing camera as subject comes into view; shoot while camera moves
Feet of subject in focus, body out	Subject moved after photographer focused	Focus ahead of subject; shoot, giving subject a little lead time
Chalky picture	Gross overexposure	Cut down exposure; use meter; check meter if used
Dark picture	Underexposure	Check meter; check use of meter
Poor background, something emerging from subject's head	Careless placement of subject in picture	Change angle, if possible; change camera position, if possible

12

Shooting Sports from Your Friendly TV Screen

The TV networks spend millions of dollars staking out dozens of cameras across the sports arenas, fields, and gridirons of the world. The two-inch to forty-inch zoom lenses of these electronic marvels reach out for the peak action in every sport they cover. What's more, a director or producer at a control panel views the screened efforts of all the photographers from their perches and, by pushing a button, shares his or her notion of the best picture or angle of an event with the viewers.

So far, the average TV image is made up of 525 horizontal lines called scanning lines. Looking at your screen close up, you can see the chainlike little lines that make up the image you see. As you move back, your eye mercifully blends all of the lines into a picture of seeming contiguous clarity. An electron beam traces these 525 lines in two sweeps of 1/60 second each. In effect, the shutter speed of your TV picture is therefore 1/30 second.

This apparent speed isn't important to the would-be photographer of a TV screen, except that it establishes a few simple rules.

1. If your camera has a focal plane curtain shutter (generally a shutter just ahead of the film plane, as in the Nikon, Canon, Minolta, Leica, Pentax, Mamiya, and others), you must shoot your screen pictures at 1/8 second or slower to stop it. Actually, Eastman Kodak's informative Customer Service Pamphlet AC-10, *Photographing Television Images*, recommends 1/8 second, but my experience has been that 1/15 works most of the time. Both these speeds require the use of a tripod or other support. If your camera has a leaf shutter (Hasselblad, Rolleiflexes of 2¼ format, 2¼ Mamiyas, Bronicas, Canon 17s, and similar front leaf shutter cameras), you can shoot your screens safely at 1/30 second.

Shooting faster—perhaps at 1/30 or 1/60 with a focal plane shutter—will often (but not always!) put a dark band across your picture. A focal plane shutter exposes the film bit by bit in a sweep of its own. When the focal plane sweep meets the TV screen sweep, you're in trouble.

Incidentally, as noted in the discussion of

shooting under arc lights, the same phenomenon occurs when you use a fast shutter speed under arc lamps, as on a racquetball court. Arc lamps have a built-in scanning flicker of their own, and at 1/250 second, depending on what stage of the scan your shutter gets, the walls of the court seem to turn a dirty gray.

I have found that the best all-around films for TV screen shooting are the following.

• For black-and-white pictures of a black-and-white screen or color screen: Kodak's Tri-X film, ASA 400. Average exposure with focal plane shutter is 1/8 at f/5.6. With a leaf shutter, average exposure is 1/30 at f/6.3.

• For color pictures (slides): Ektachrome 200 daylight film. With a focal plane shutter, set 1/8 at f/5.6. With a leaf shutter, set 1/30 at f/5.6.

As noted above, a focal plane shutter speed of 1/15 will often give good results. The lens opening, when trying 1/15, should obviously be a stop higher than the exposure at 1/8. In other words, use 1/15 at f/4 instead of 1/8 at f/5.6.

Kodak's suggested camera settings for shooting TV images are shown below.

As you can see, Kodak recommends the use of a 40R (reddish) filter over the lens—gelatin or glass filter—to correct a certain amount of blue-green in the average slide shot from the TV screen. This involves adding another stop to the exposure. For average home use, the filter is a luxury. Daylight color film is quite forgiving in this situation; buy the 40R filter if you plan to shoot lots of TV.

For shutter-priority automatic cameras, place your camera in front of the screen on a tripod, focus on the screen, set the shutter at 1/8 or 1/15 if it is a focal plane shutter, then try to capture whatever you can of the great football, hockey, or basketball game. It will feel eerie at first, trying to shoot action at such a slow shutter speed, but your first roll should convince you that it can be done.

KODAK Film	Use for	Black-and-White Television Set		Color Television Set	
		Leaf Shutter	Focal-Plane Shutter	Leaf Shutter	Focal-Plane Shutter
VERICHROME Pan Plus-X Pan	Black-and-White Prints	1/30 sec f/4	1/8 sec f/8	1/30 sec f/2.8	1/8 sec f/5.6
Tri-X Pan	Black-and-White Prints	1/30 sec f/5.6 ↓ 8	1/8 sec f/11 ↓ 16	1/30 sec f/4 ↓ 5.6	1/8 sec f/8 ↓ 11
KODACOLOR II*	Color Prints	1/8 sec f/2.8		1/8 sec f/2.8	
KODACHROME 64 (Daylight)*	Color Slides	or	1/8 sec f/2.8	or	1/8 sec f/2.8
EKTACHROME 64 (Daylight)*	Color Slides	1/15 sec f/2		1/15 sec f/2	
EKTACHROME 200 (Daylight)*—with Normal Processing, ASA 200	Color Slides	1/30 sec f/2.8	1/8 sec f/5.6	1/30 sec f/2.8	1/8 sec f/5.6
KODACOLOR 400	Color Prints				
EKTACHROME 200 (Daylight)*	Color Slides	1/30 sec f/4	1/8 sec f/8	1/30 sec f/4	1/8 sec f/8

IMPORTANT: With leaf shutters, use a shutter speed of 1/30 second or slower. With focal-plane shutters, use a shutter speed of 1/8 second or slower to avoid dark bands in your pictures. With shutter speeds slower than 1/30 second, use a tripod or other camera support. See discussion on page 4.

NOTE: The symbol ↓ indicates the lens opening halfway between the two f-numbers.

* Pictures of color television taken without a filter will look somewhat blue-green. With the color films in the table, you can use a KODAK Color Compensating Filter, CC40R, over your camera lens to help bring out the reds in your pictures. Increase the exposure suggested in the table by 1 stop. The use of the CC40R filter is not recommended for KODACOLOR 400 Film. With this film you don't need a filter.

The instant replay is a boon to the armchair sports photographer. Those frame-by-frame replays of the foot going out of bounds, the ball touching the boundary line, or the moment of ball-to-racquet impact provide good practice for eventually leaving your TV set and getting the real thing in your camera sights.

The newcomer to sports photography can learn a great deal from watching the way a TV network covers an event.

The long telephoto lens catches the huddle, close-up, and even the hands of the quarterback waiting for the snap. The zoom pulls back, or another camera angle is used, and we see the entire lineup of offense versus defense. The ball is snapped and we follow the runner. If the play is a pass, another lens zooms downfield with the putative receiver and still another on another possible receiver.

Obviously, the beginning sports photographer doesn't usually have the equipment or the mobility to cover a game the way it is done on TV. Actually, neither does *Sports Illustrated* magazine. But the perfection of the zoom lens and the long telephotos for the still photographer—work done primarily by Nikon, Canon, Pentax, and Vivitar—has made it possible for the still photographer to come close to capturing the peak action of a sports event.

The basic lessons for the novice sports photographer watching TV follow:

1. The long telephoto is used for filling the screen with close-ups of crucial action—the great catch, the key hockey goal, the slam-dunk that tied the score.

Thus, the sidelines or grandstand photographer wanting to come home with a TV-type close-up must concentrate on following the action with a longish telephoto or, better, a longish zoom. (See the discussion on choosing the right lens in Chapter 2.)

2. The normal and wide-angle lenses are used to set the scene. Surprisingly, the meek sport of shooting the TV screen from a tripod is good practice for the would-be sports photographer. It provides an excellent opportunity for you to fill your camera finder with a succession of peak images—the kind the good still sports photographer tirelessly seeks through the finder of his or her motorized camera.

Once you have learned some pointers from watching TV or studying the pages of sports and general magazines for the kind of sports pictures that immediately compel your interest and the interest of the editors who bought the picture, you are ready to create some of them yourself.

Shooting the TV screen eliminates the sideline trudging, the mud, rain, snow, the pushing of your competitors, the hassles with guards, and, thanks to the guidelines offered above, most of the worry about exposure.

13
How to Sell Sports Photos

One of the delights of sports photography is that once you have become relatively proficient at producing good coverage of an event—of individuals in action, of animals, boats, iceboats, sand buggies, and the like—it is but a short step to making your new skill pay!

If you are the sort of photographer who doesn't mind commercializing or indeed, has to commercialize to support the film habit, there are many avenues and vistas immediately open.

Before setting out on this path, however, there are some questions you must be able to ask and answer honestly. If you can honestly answer yes to each of the questions below, you are probably at the starting gate. If a few of the questions give you trouble, don't start until you are fully prepared. Nothing is more embarrassing than blowing an assignment or a single picture. At an early stage in your development as a working sports photographer or semipro, if your pictures don't come

out, you will have closed a door for yourself that might have become a lucrative account.

It's something like learning to ride a bike. It appears to be impossible at first, then kind of shaky, then, all of a sudden, you have the knack and can go almost anywhere. Trying to go anywhere at the shaky stage just does not work.

The questions:

• Can I take well-exposed black-and-white and color shots of football, baseball, track, basketball under daylight as well as the various kinds of artificial light in stadiums?

• Can I use my telephoto lenses well enough to get close-up pictures of, for instance, a play at second base? Am I proficient with my automatic winder or motor drive, or can I rent or borrow one for an important job?

• Is my personal processing setup or my professional lab equipped to develop, make dupes and/or prints?

• Is my equipment, including at least one backup camera body, consistently dependable?

Is there any "sometimes it seems to . . ." type of malfunction that clears up when you get to the counter of your friendly repair person?

• Am I bold enough to set a price to cover my efforts and expenses?

• Am I comfortable with the whole idea of covering an event?

• Do I enjoy being the only photographer on the scene?

The hallmark of the amateur or shaky semi-pro is this kind of statement: "I don't really have to worry about getting good pictures. That other photographer with all those lenses seems to know what he or she is doing, so the team (or the family, the school paper, the Sunday section editor) will have *something* even if my film is blank." The point, of course, is that you must have confidence in your own photographic ability. If you've shot a blank roll along the way because you loaded the camera wrong, you'll make doubly sure that the film is threaded correctly next time.

You'll learn to carry spare batteries, film, and a tripod perhaps.

MARKETS FOR SPORTS PICTURES

There are only a few basic markets for your sports photos, but the possibilities for sales within these groups of potential buyers are fantastically numerous. When the sports photographer first dips a tentative toe into selling pictures, the best pool of customers at the local level will undoubtedly be the athletes and their families. This basic category also includes the owners of show dogs, cats, and horses, as well as the other less common pets that the photographer runs across. (How could the owner of a pet lizard resist a close-up picture of the little beast with its three-inch tongue forked out, zapping an insect?)

Generally, the beginning sports photographer is quite welcome at most events if he or she sticks to the basic rules of sports photog-

Marketing your photos can be as easy as photographing and selling individual and team pictures at the local high school.

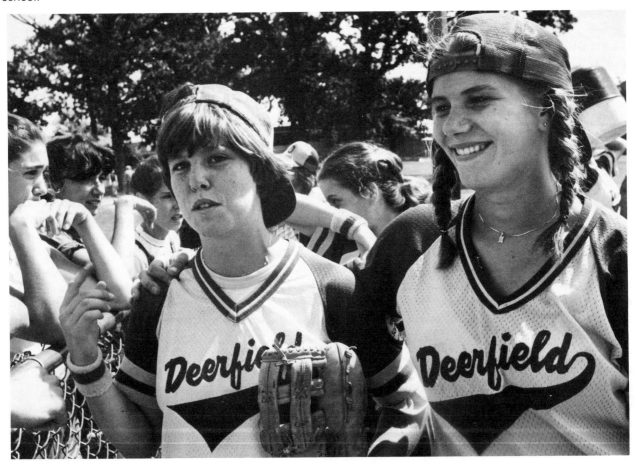

raphy: Don't block the view of someone behind you who paid for that seat. Don't leave the sidelines to race on the field during play or time-outs for a better shot.

The trick is to keep a low profile, be courteous to athletes and bystanders, and keep your equipment to a minimum and on your person. That is, *do not leave your equipment on the sidelines or near players warming up or otherwise practicing.*

The tripod is taboo on most sidelines because athletes have been hurt by tripping over them. Also, tripods and expensive cameras and lenses resting on them have been clobbered.

On the positive side, let us consider how an up-and-coming sports photographer interested in making his or her hobby pay might go about covering a high school football game for fun and profit.

It's early in the season and Lincoln and Washington High are to play each other next Saturday afternoon at your hometown Lincoln field. You attend Lincoln and have a single-lens reflex camera with a normal lens and an 80–210mm zoom lens. You have a winder that lets you shoot three frames per second. You've shot a few pictures of the team practicing, even sold a few 8x10 prints to three of the players when you caught them up in the air on a pass interception in practice after school one day. You charged each player $3 a print and felt pretty good about the whole thing because the coach asked for a copy, which you supplied free. The school paper also asked for a free copy, and they printed the picture but forgot to give you a by-line under it.

Early in the week you stop by the school's athletic department office and ask the person in charge of publicity or public relations for a sidelines pass and a copy of the rules for photographers that most schools provide.

"Where are these pictures going to be published?" asks the publicity person.

"Well, I'd like to try them on the *Lincoln Log* downtown."

"They'll have their own photographer there, Susan Snap. She does terrific football pictures."

"I know, but I want to capture the mood of the game, the tension on the sidelines, and also the halftime activities." (Local photographers assigned to cover the game rarely bother

much with shooting halftime activities.)

You might add that you plan to submit a few prints to the Washington High paper and something on Washington's star quarterback to the Omaha paper, which ran a story about the university scouts looking at him. Also, there's an annual contest Kodak runs for high school students and you'd like to make sure Lincoln High is represented. Finally, a few of the guys asked you to try to get some action shots of them on the field.

Leaving out the technical coverage in this section, there you are, zoom lens on camera, getting your best pictures on plays coming toward you in one end zone or the other. A Lincoln halfback scores on a beautiful play that sends him five feet in the air, arching like a diver over the defending line. You got the shot with the halfback in the air coming at you to the goal. You notice that the great Susan Snap was off to the left loading film when the first-down touchdown play occurred. You can tell from her expression (one that will often find itself on your face if you continue in sports photography) that she's disgusted with herself.

This turns out to be the only touchdown of the day.

A woman comes up to you on the sidelines and gives you her card. She is president of a local advertising agency. "That was my boy who made the touchdown," she says. "I think you had a fine angle on that touchdown play. Could you sell me about six prints? As a matter of fact, our agency uses lots of action pictures for ads. Why don't you bring your portfolio in when you come with the prints?"

During halftime, eight members of the cheerleading squad ask you to shoot their pyramid but to be sure to get the crowd in the picture as well. You also get a frame of a dog chasing a rabbit across the field.

A little boy and girl of kindergarten age have been doing fantastic baton tricks at halftime. Their proud father comes up to you, holding out his card. "We have a club," he says. "About twenty kids are involved in this premajor and majorette program. We have two psychologists who are running a study on teaching poise to kids by giving them a tough job to do that you would imagine is beyond them." Not only does this situation have great selling possibilities for you among the parents

of the kids, but you also may have the beginnings of a fine magazine story, certainly a Sunday feature story.

If you have the literary ability it takes to write a good descriptive letter to a friend, you can supply the average editor with enough information to go on or at least to begin working on a story. And, of course, you have all those good game action pictures in black and white, color, or both.

If you've shot in black and white, the thing to do is to post your contact prints on the bulletin board of the athletic office. Leave a lined piece of paper next to the pictures, with a typed note that says: You can get 5x7 or 8x10 blowups of these pictures. The price for a 5x7 print is (let us estimate and change with the economy) $2.50, an 8x10 is $3.50. Please notice that each contact sheet has a number and each frame has a number. If you want to buy a print, leave your name, address, and phone number on the sheet, with contact sheet number and frame number, plus number of prints of each frame desired.

By now you should have cards printed, and should tack a few of these to the bulletin board so that potential customers for your photography can find you easily.

This would be the best of all possible times to set up a filing system, so that a year from now, if one of the players decides to reorder a few prints for a girlfriend, or *Sports Illustrated* comes to you for an early snapshot of a superstar, you can go to your card index file and find what's needed. A simple filing system is all that's needed. The file card might read:

FOOTBALL Lincoln–Washington game (10/14/81): nine rolls black and white, three color. Cheerleader, halftime activity. Young baton twirlers. Picture of dog chasing rabbit across field, past football huddle. Pregame close-ups of most team members. Good warm-up pictures of players stretching and doing calisthenics.

Ideally, you should file your negatives with a set of duplicate contact sheets. *Poor filing systems, such as the inability to retrieve pictures that exist, cost photographers millions of dollars each year.*

If you shoot slides, there are plastic pages available for filing your best frames, while keeping the bulk of your takes in the lab's or Kodak's little boxes. Deep, larger envelopes can be used for these bulkier boxes. At least that's what most magazines do.

If you can't sell that dog-chasing-rabbit picture to your local paper, you might try the biggest wire service office, AP or UPI, in your area. Just ask for the picture editor and say, "I don't know if you had anyone covering the Lincoln–Washington game, but there was this dog chasing a rabbit . . ."

He or she, probably intrigued, might also like to see those minuscule majorettes.

Animals, kids, and athletes are three very salable categories to picture editors of all kinds.

The point is that once you regard your photographic activities as potential income producers, the first thing that happens is that customers begin to appear at a rate you probably never thought possible.

As your name becomes known, you will soon know how to rebuke the individual responsible for leaving out your credit line. After a few photographic sales or successes, your name will come up at camera store counters, at the local paper, and down at that woman's ad agency, especially if you followed through and took in some prints of that great play, plus a few other good prints—that portfolio she asked to see. (More on portfolios on page 109.)

GETTING BUSINESS

Ideally, you will be discovered by your local sports editor, and the regional sports editors and wire service editors will keep you hopping from one event to the next. They will begin to accept collect calls from you as you start making suggestions for picture stories and features.

If this doesn't begin to happen soon enough for you, there is a surefire way to begin. The scenario will vary, of course, but the elements remain the same.

Here you are with an interest in sports photography and the basic ability to take good sports pictures. Out there are numerous teams, players, parents, friends of performers, and so on. The trick is to make your abilities, availability, and interest known to them.

The best pool of potential picture buyers for the beginning sports photographer with a commercial turn of mind is the loved ones of Joe or Jane Athlete. No parent can easily turn down a picture of an offspring skating, batting, jumping, winning, charging the net or an opponent's line, hitting the tape, aiming an arrow, steering a Star class sailboat, etc.

Pet owners fall into the same category as do boat owners and hang glider pilots.

Amateur sports photographers take hundreds of good pictures of all of the above and, invariably, somehow, they never take the next step—selling the print or slide.

The sports photography beginner who is serious about the business end of the profession must evolve a simple retrieval system, as they say in the computer world.

Many sports involve athletes wearing numbers. These numbers are usually keyed to a printed program. The photographer should secure several of these programs and key his or her pictures and identifications to these programs. Walking around during the warm-up period before a gymnastics meet, for example, the photographer should be able to get an idea of which gymnasts' parents (in the case of young performers) might like to have a sequence of pictures of their star family performer.

Photographers on sidelines all over the world grow accustomed to nice people coming up to them and asking, "Could I ask you to take a picture of my son (or daughter, husband, boyfriend, wife), number 23? He'll be fourth on the parallel bars. I see you have a motor drive camera. Last time I tried to shoot him, I couldn't get close enough and my shot was blurred."

This is the time to take names and addresses and tell your potential customer what your rates are. If you keep these rates fairly low, you should easily be able to make a 200 percent return on your film and processing costs. Most labs give you a discount for prints in quantity so that the three prints you order may cost you $4.50, and your client should be glad to pay $10 or more for them.

The prices and costs will, of course, vary with the fluctuations in the economy. The cost of materials is decidedly a factor in pricing your pictures for general customers. But other factors to consider include: Were you asked to take pictures of an athlete by a financially responsible person? Does the entire team want copies of one group picture? Will you be able to put your proofs or contact prints up on a team bulletin board, facilitating the sale of your pictures? Are your subjects poor kids for whom even a couple of dollars for a print would be cutting into lunch or bus money?

All these considerations must be dealt with along with your own objectives before you go into the business.

If you're a successful business person who loves to take pictures of sporting events with long telephoto lens and extender, you might enjoy donating a few prints to the school paper or yearbook or perhaps lending black-and-white negatives to the school's photo club or class so that they might make prints for the team or the school's publications.

It is not fair for the photographer to ask a subject, "Well, what are they worth to you?"

On the other hand, dealing with ad agencies, many of which use pictures merely for layout purposes or to draw from, often becomes a traumatic experience for the young pro or would-be pro. Newcomers might be tempted to go along this time by charging a minimal sum for a great picture so that next time they need a good sports picture they will give you a good assignment.

It is the experience of most magazine photographers I know that each "next time" is a new ball game, often played with a tighter budget than the last one.

One question I have found useful in dealing with advertising buyers is, "How much can you pay me without getting fired?"

As a jumping-off point on the perilous journey into selling pictures, it is recommended that you establish a mental day rate. That is, decide in your mind that you are worth, say, $100 a day plus expenses to anyone, *including yourself,* who wants you to shoot for more than four hours (including transportation time). Expenses include transportation, parking, tolls, film, processing, and shipping.

Note that on some rare occasions, before you are established, it may (sob!) be necessary for you to *pay* your way into a sports arena or stadium. This cost, of course, should be reim-

bursed by your client if you are hired to cover an event. It should, however, sharpen your resolve to use the telephone creatively and make that call to the athletic department public relations person early in the week of an event, or even farther in advance.

Minimally, you should ask for a sidelines pass, general admission, or a press pass, and ask for the restrictions and rules, immediately establishing that you are a responsible, cooperative photographer who is not going to set up a huge tripod on the sidelines that will ensnare the legs of a star hoopster.

The degree of difficulty in getting in free increases the higher up the sports scale you ascend. It is easiest at local, park, and high school games. It gets a little tougher at college games. Professional baseball is the easiest sport to which the new sports photographer can gain free admission. There is generally a special press gate monitored by a couple of nice, glazed-eyed attendants who have seen everything during the past thirty years. Now they're seeing you, a name the front office called down. Of course, World Series and playoff games are harder to get into, so warm up on ordinary games.

Your telephone request should not be a blatant lie, but most teams are eager for the appearance of a fully crowded park at a non-crucial game, and in general welcome photographers of all kinds. If your story bends the truth a little, no one will mind. For example, if you're really at the ball park to test your new 400mm lens and its extender, you might say, "My name is John Doe. I'm a sports photographer. As a matter of fact, I photographed Charlie Speedy at the park district awards night. Anyway, I'm working on a series of close-up action shots that I plan to submit to such-and-such magazine." Note: Thou shalt not lie and say, "I am shooting *for* such-and-such magazine." The chances are that the public relations people *know* the local photographer used by that magazine and will grill you as to who assigned you, the job, etc.

"I plan to submit" or "I hope to try it on" are more honorable approaches.

As you become more experienced or better known, you will be able to ask for a parking pass and a ticket for your assistant. When it becomes known that you can get into games and events free, you will have a ready supply of free assistants who are eager to carry your heavy tripod and long lenses in return for free admission.

It is a good idea to have business cards printed as soon as you feel ready to sell your pictures. Just standing or sitting on the sidelines and shooting through your telephoto will bring you a parade of sports photography fans. These will be made up of two groups.

The larger group will be would-be sports photographers quizzing you on lenses, film, what you are doing, what camera one should buy to shoot Hawaii on one's vacation, and so on.

The second, smaller group will want to know if it is possible to get pictures of player so and so, or game action? This is the group that may produce a few sales, so hand them your card when you've established the fact that they are potential buyers of your sports pictures. It's only one tap of the shoulder from this situation to, "Can you come around some Sunday and shoot my kid's Little League team? We'd all be willing to pay for good action shots of our kids. We all have cameras, but our pictures are all blurry."

Some years ago, after missing a great sports picture because some amateur was peppering me with questions, I had a photographic cliche card printed and would check various lines on it, silently handing it to inquisitors. *Popular Photography* magazine reprinted it, and I still get requests for it. This is what it said:

> Pardon this rather perfunctory way of answering your interesting questions, but I am working just now.
> —The long lens brings things up close.
> —About $500.
> —Yes, there is enough light to shoot in here.
> —Oh, they blow them up, etc, etc.

PORTFOLIOS

There comes a time in the life of a budding sports photographer when he or she wants to

branch out beyond the local markets—maybe to the next big town, or to a really big town, or to New York City, to let the picture buyers of *Sports Illustrated, Sport Magazine,* or *Inside Sports* know that you are available for assignments out in Lincoln–Washington High School territory and beyond.

What does an editor want to see?

He or she wants to see something different from the basic bread-and-butter cliche pictures that come across the photo desks.

How many times have you seen the basketball in perfect position, covering a player's head so that he or she looks like a melon head? Maybe five or six times, right? The poor editor has seen it a hundred times. If you shot a picture like this and have something better, show the better one.

One year during spring training, a *Sports Illustrated* photographer put a catcher's mask over the front of a wide-angle lens and shot a catcher's eye view of a ball coming in past the batter, plus some nice wide-angle views as from behind the bars of the mask.

The pictures ran in *Sports Illustrated* and have been running ever since in imitations all across the baseball pages every spring.

For a portfolio—and no more than twenty prints should be shown to these busy editors, plus a few tear sheets of published sports pictures if any—any picture that shows your alertness or imagination will be sure to impress an editor.

That shot of the dog chasing a rabbit would be a good one. The cute little drum major and majorette couple, if not cloyingly cute, might work.

If you have access to a tele-extender lens for that zoom, you should submit a good telephoto shot of the classic attempted steal shot at second base. This simple picture situation, coverable from the third base or first base side, shows an editor that you have enough lens to reach out for a distant but crucial scene.

Your touchdown picture of the player coming right at the camera would be fine, but another good bet is the toughest of all football action pictures—a shot of a pass being caught or an interception in progress.

These last two are so tough that the TV cameramen generally do isolated views of two or more players going out for passes, and when they get the ball coming to one of the people they've covered, the producer screens the exciting play for the viewer.

The still photographer must outguess the play, and luck becomes a factor in getting this picture, as does developing a feeling for a sport. Most sports photographers bring this feeling to the art of shooting sports, because it is this feeling that developed into the urge to document on film what the eye has seen.

Your portfolio should include at least half a dozen close-ups of people engaged in sports activities. By close-ups I mean pictures that show the strain, the agony, the joy, the concentration, and the other facial expressions and emotional peaks that the telephoto lens is capable of capturing.

Aside from the plague of bad exposures and out-of-focus pictures that amateur photographers seem to suffer when they begin to handle telephoto lenses, *the single most common failing of the new photographer is not getting enough close-up pictures!*

This apparent timidity to fill the finder with the subject is not limited to sports photography. As a photography teacher at several colleges and numerous clinics, and a judge of portfolios and press photography competitions, I have always been amazed that the eye of a photographer capable of seeing a great shot and capturing it often lacks the final 15 percent of capability, boldness, or selling vision to frame the picture a little tighter.

Of course, good editors will crop mercifully and bring up a worthwhile central area, but the editor is often harried and wants to be overwhelmed by a picture rather than be forced to blow up a small area of one and wonder if its sharpness can carry over a full page or two.

In black-and-white sports photography the photographer generally has a little more control and can usually crop in the enlarger and submit the core action shot that seems to express that wonderful moment of truth seen fleetingly in the finder.

Of course, the price of film has been increasing, but the would-be picture marketer *must* learn to shoot heavily and to discard bad frames heavily to compete in a tough market.

It should encourage some and discourage others to know that *Sports Illustrated* generally uses at least two photographers to cover an important football game. Each photographer, using up to four motor-driven cameras averaging five frames a second usually turns in thirty-three rolls of film. Sixty-six rolls times, say, thirty exposures on a roll (rolls come out partially shot during time-outs) gives approximately 2,000 color slides to the picture editor. From these 2,000, the six or seven smashing shots used, plus a possible cover, are chosen.

Of course, in the beginning your portfolio will not be designed to be shown to the picture editors of the big sports magazines. You will be out to impress your local picture editors. These people are newspaper people and, in general, they have a good grasp of what their readers like. Hard action pictures come first, especially when the pictures document a crucial play or important player. Next comes cute.

Alas, cute covers yet the next basketball head picture you will see, the three-year-old son of the star pitcher winding up while sitting in the bullpen or on daddy's shoulders, the team's mascot—that buffalo with a mock Indian riding him, bow and quiver courtesy of the local sporting goods store.

So, your portfolio should have a couple of cute pictures—maybe your pooch retrieving a Frisbee or, by a trick of perspective and with thanks to your new zoom, the dog seeming to retrieve a 747 passing overhead.

If you have a good satirical eye, using your 200mm zoom plus extender should give you a few cartoon-type cute pictures ("cute snaps" is what one *Life* editor called them) of players clowning before a game. Those wads of chewing tobacco contort players' faces; vast bubble-gum bubbles explode and cover faces; dogs and kids run onto the field; a guy sticks peanuts in his ears. I covered the coming of big league baseball to Milwaukee on a rainy night, and *Life* used my picture of a fan standing on his head on the infield tarp as its big picture for the story!

If you're in a cold weather area, your portfolio should have some good snow-sport and snow-fun pictures—hot dog skiers, kid skiers, snowmobilers going over knolls, an ancient ice-skater, or a couple still dancing after fifty years of marriage, and so on.

The quality that most editors look for is a kind of self-contained cartoon effect, a picture that the reader wants to tear out and show the guys at the office or the family at home. It is my belief that the good sports picture often comes closer to a good humorous (or serious) cartoon than it does to the straight average news picture that shows the food plant on fire.

Somehow, you must learn to edit your own picture selection so that you don't burden your portfolio (and your potential editor) with an entire sequence of one player and his or her bubble gum. Pick the best frame and blow it up and go with it. It may, of course, be that a series of three of four of these shots makes a fine sequence. In these days of the motorized camera and winder shooting up to six frames a second, it's a good idea to have a sequence in your portfolio. If you have one, make sure you are not displaying the same picture five times, that there is a good reason for showing the sequence. The caught pass, the catcher's scramble for the goal line, the umpire's hands raised, the pandemonium around the hero makes a good sequence, rather than the ball in the air, coming closer, and closer, and being caught.

KEEPING A GOOD FILE

Once editors and team PR people know you and your work, they will begin to call you for pictures of various events or participants. Being able to retrieve these quickly involves starting a good filing system. Keep a scrapbook of newspaper and magazine sports pictures that impress you. Keep looking at them, at their solution of the common sports photography problems—angle of view, distance from subject. Try to beat these pictures next time you're out shooting.

14

Specific Markets for the Sports Photographer

The most difficult magazine for the beginning sports photographer to hit is *Sports Illustrated*. *Sports Illustrated* occasionally uses a fantastic sports shot done by an amateur if the shot illustrates an article that is already in the house. My first sale to the magazine was a color shot of a robin in a snowstorm, and the magazine actually assigned an ornithologist to do an article to accompany the picture, explaining why the robin was in the snow.

John Dominis, *Sports Illustrated* picture editor, generally claims to young would-be photographers that he doesn't really have enough work to give to his old reliable photographers. Still, he likes to see the portfolios of new sports photographers, especially those of people who specialize in a single sport such as gymnastics or swimming.

The day rate is en route to $300 a day against $450 a page and up to $1,000 for a cover.

Sport Magazine, also in New York, doesn't use as many pictures as *Sports Illustrated* but likes to look at portfolios of sports photographers and occasionally assigns pictures to

those photographers who seem to have promise. Their rates are somewhat lower than those paid by *Sports Illustrated*. *Inside Sports* is a new magazine that uses many pictures.

Actually, *Life* magazine is probably a much better market for the single fantastic sports picture than the specialty sports magazines. "We're interested in great pictures. Period." says picture editor John Loengard. Occasionally, *Life* will assign a photographer-suggested idea, guaranteeing the photographer a day or two of shooting at $250 a day plus expenses against space rates of $400 a page and up.

If you are serious about becoming a selling sports photographer, the first thing you must do after you have developed your skills and are equipped well enough to cover most sports in daylight is to study your markets.

You must go to the library and go through the back issues of *Sports Illustrated, Sport Magazine,* the nature magazines such as *Sports Afield,* the gorgeous magazines such as *National Geographic, Geo,* and *Smithsonian*— and study them.

How do the published photographers cover action shots—kids running, actual sports being played under exotic or not so exotic conditions?

In football coverage (if you are interested in shooting that rough sport), are the best pictures of running backs, pass receivers, the defense, the huddle, the sidelines, or a mixture of all? When a portrait is printed, is it shot by natural light or artificial light? Is a reflector pouring light into an otherwise shadowed face?

What about long-focus telephoto lenses versus shorter lenses? Is the action stopped dead by high shutter speeds or is there a bit of a blur around the fast-moving feet or churning arms?

Are you ready to shoot the same kind of pictures, that is, are you confident enough to compete with the pros whose work you are studying?

Examine some of the more general magazines that occasionally cover sports—magazines like *People, Life,* and even the supplement, *Parade,* which appears in several hundred papers each weekend.

After much poring over these pictures you will develop a feeling for how important sports coverage is and see that sports pictures figure prominently in these publications. The same is true of the airline magazines such as the superb *TWA Ambassador,* the Diners' Club *Signature,* Allstate's *Discovery,* and the East–West Network airline publications.

The good news implicit in a lengthy perusal is that magazines do indeed use lots of sports pictures. The bad news, for you, at an early stage, might be that the pictures used are smashingly sharp, well composed, perfectly exposed, and exciting.

The answer is that most picture editors of the top magazines are used to going through several hundred sports pictures before choosing the one that suits their story.

There are aviation magazines, boating magazines, dog, cat, tennis, racquetball, and myriad other magazines to examine. When you see a bad picture—a blurred one, an overexposed color shot—you'll know that somehow at least one editor didn't get exactly the picture he or she had hoped for. This should give you hope. *Your* pictures will be great, right?

There are perhaps ten good photographic marketplace books in the average local library. The *1980 Photographer's Market* (published by Writer's Digest Books, Cincinnati, Ohio) is probably the best of these, although for some reason its latest edition doesn't mention *Life* Magazine. It does, however, mention more than 3,000 other places that buy pictures. Many of these markets use sports pictures but pay very little for them. In many cases, $15 is minimum.

The virtue of this informative book, however, is that it shows the depth of the photographic market. Photographic agencies that are called stock agencies are listed, and the terms for working with these organizations are explained. For example: "Uses 8x10 prints. Wants people in the news only. Can use 35mm color transparencies. Wants scenics, animals, sports action, landmarks."

The book lists technical services and labs all over the country without specific recommendations.

I have had excellent processing in black and white and color of sports photographs from the following labs:

In Chicago, Illinois:

Gamma Photo Lab, 314 W. Superior St., Chicago, IL 60610. (312) 337-0022. Ben Lavit, Manager.

Astra Photo Service, Inc. 6 E. Lake St., Chicago, IL 60601. (312) 372-4366. Harold Smolin, Manager.

Pallas Photo Labs, Inc., 319 W. Erie St., Chicago, IL 60610. (312) 787-4600. Rusty and Mickey Pallas, Managers. Denver Branch: 665 Kalamath, 80204. (303) 744-8333.

In New York City:

Portogallo Photographic Services, 72 W. 45th St., New York, NY 10036. (212) 840-2636.

Kurshan Color Labs, 209 W. 40th St., New York, NY 10018. (212) 398-0500.

Weiman & Lester, 106 E. 41st St., New York, NY 10017.

Berkey K + L Custom Services, 222 E. 44th St., New York, NY 10017. (212) 661-5600.

In California:

Berkey Film Processing of Los Angeles, Inc., 3400 E. 70th St., Long Beach, CA 90805. (213) 634-5831.

REPAIRS

Most of the camera manufacturers maintain repair facilities in three or four parts of the United States. Your local camera store can tell you where these are. Generally, the charges are high but fair.

In my personal experience, the best repair shops in the country are:

1. Marty Forscher's Professional Camera Service
 37 W. 47th St.
 New York, NY 10036
 (212) 246-7660

Forscher's forte is modification, but he can fix or recreate almost anything, and he is known for his honesty.

2. Dempster Camera Shop
 4845 W. Dempster St.
 Skokie, IL 60077
 (312) 679-5619

Photographer's Market also lists advertising agencies and public relations agencies across the country, some of whom are specifically helpful. The entry for Manning, Selvage & Lee, Inc., a huge PR organization with offices in New York, Chicago, Atlanta, Los Angeles, St. Louis, Texas, and Canada, gives an extremely helpful rundown of what the agency expects of a photographer, and states the importance of the photographer's approach and appearance, which must be acceptable "to somewhat conservative corporate executives."

Chicago agency head Herb Krause tells me, "The sports photographer can dress in sneakers and jeans for baseball sideline shots of players, but to do a portrait of the head of one of our clients' sporting goods divisions out there on the field just before game time, looking at a product with a player, the sports photographer would make a better impression wearing a sport jacket with tie."

Listed too are consumer publications such as *Volleyball,* a California magazine that pays "$10–20" a photo and will look at contact sheets rather than have the photographer go through the trouble and expense of printing his or her best frames.

Numerous nature magazines (most states have them) are ready to buy your beautiful scenics. Sunday sections of big city newspapers are always looking for feature stories on sports figures who might do something interesting outside sports. The reverse situation is also attractive to them: celebrities in other fields who do something worth publishing in sports.

You can ask your friendly librarian for a listing of photo market books, but, as noted above, the Writer's Digest *Photographic Market,* which is revised each year, will keep you going for many a day.

If you can't find a copy of a magazine that sounds as if you'd like to submit some of your great pictures to it, just get the address from any of the marketing books and write the editor. Here is a sample letter.

Dear sir or madam:

I have heard of your fine magazine but haven't been able to find a copy in my area. Could you please send me a sample copy or two of representative issues? I'm a sports photographer and I backpack several months a year, so I may be able to submit something to you. Do you have a guideline and rate sheet for photographers? If so, I'd like to have one.

Thank you,
Betty Hopeful

PS: I have a picture of an eagle scooping up a rabbit. It's on Kodachrome, vertical, and if you express any interest in it, I'll submit it as a cover possibility or article illustration, perhaps for a story on eagles.

Most magazines are glad to hear from potential freelancers because their care and upkeep is absolutely free, less a little postage money. And sometimes they come up with fantastic, exclusive, unsolicited stories that make a magazine and its editors look as if they were the best planners in the world!

Is it necessary to tell you—the young, eager, hopeful sports photographer—to dress neatly, be properly barbered, and make sure your prints and/or tear sheets are neatly mounted?

If you are asked what your objective is in going to see an editor because you know the publication has two full-time sports photographers, your answer should be something like: "Yes, I know their work very well and

admire it. But sometimes one of them might be on vacation or on a day off. Or sometimes you may need an event covered while they are both shooting something else.''

In essence, your portfolio visit must be like any other sales foray. You must sell yourself, your work, your attitude, and your availability. Your pictures must be devoid of spots and you shouldn't apologize for your lost picture opportunities.

Good editors are delighted to have the names of eager young (or eager old!) photographers who have specific interests. They will generally warn you that the chances of getting work from them are slim, that their rates aren't too good. The first thing you know, you'll be canceling your dinner plans one Sunday to cover the visiting Chinese gymnastics troupe.

I have not, perhaps, dwelled heavily enough on the photographer's attitude towards sports photography. I assume that love of sports and love of photography have conjoined to bring you to the starting gate of a fine possible career.

One year I photographed eight of *Sports Illustrated's* lead football stories. Standing in the mud just behind me one day was a famous writer doing an article.

"Why do you do it?" he asked me, pointing to the mud, the gear, the crowd.

"A sporting event is a one-time occurrence," I said. "You take pride in getting a good picture of something that happens in the wrong light, the wrong place and while you'd rather be changing film."

"It's a challenge" he said. "You against the sport. And you have to win because . . ."

The game ended at the goal line. We were run down by frenzied fans.

"Why are *you* down here?" I asked.

"Never thought about it," he replied with a muddy smile. "It's fun, I guess."

"That's it," I said. "It's lots of fun, the pay is great, and you get to see your work and your name in print a lot."

Now, a long time and a far place from that goal line I can add that sports photography is the toughest school in the world for learning the art and the craft of photography. Having to do everything at high speed accelerates the learning process.

Good shooting!

Index